GH00732076

A LADAKHI DIARY

WITH WATERCOLOURS OF A HIMALAYAN TREK IN 1929

BY

MOLLIE MOLESWORTH

Trotamundas Press

First Published in Great Britain in 2010 by Trotamundas Press Ltd.
The Meridian, 4 Copthall House, Station Square, Coventry CV1 2FL, UK.

Trotamundas Press is an international publisher specializing in travel literature written by women travellers from different countries and cultures.

www.trotamundaspress.com

All rights reserved. No part of this publication may be reproduced, stored in a retrieval system, or transmitted, in any form, or by any means, electronic, mechanical, photocopying, recording or otherwise, without the prior permission of the publishers.

"A Ladakhi Diary – With watercolours of a Himalayan Trek in 1929" by Mollie Molesworth
First Edition

copyright © Sheila Harvey, Jenifer Rohde 2010
copyright © of this edition Trotamundas Press Ltd. 2010

Cover design and layout: Maurizio Costanza (www.e-mage.it)

Photography by Julian Huxley-Parlour

Map design by David Foley

Helpful advice given by Chris Beetles of Chris Beetles Ltd.

ISBN: 978-1-906393-24-3

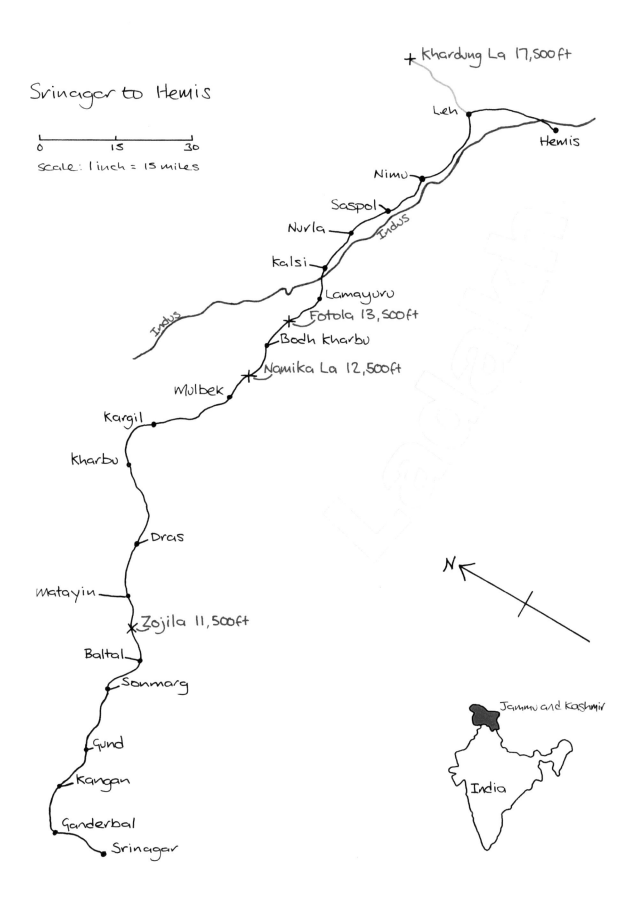

Srinager to Hemis

scale: 1 inch = 15 miles

Khardung La 17,500ft

Leh

Hemis

Nimu

Saspol

Nurla

Indus

Kalsi

Lamayuru

Fotola 13,500ft

Bodh kharbu

Namika La 12,500ft

Mulbek

Kargil

Kharbu

Indus

Dras

Matayin

Zojila 11,500ft

Baltal

Sonmarg

Gund

Kangan

Ganderbal

Srinagar

N

Jammu and Kashmir

India

CONTENTS

ACKNOWLEDGEMENTS

Jenifer Rohde and Sheila Harvey, Mollie's nieces, would like to thank all those who have given their help and support to this project. Our particular thanks go to Dr Jeremy Harvey for his introduction: David Foley for his map of the trek: Dr Ben Harvey for his background research: Beatrix Molesworth for her safekeeping of one of the diaries and for her invaluable personal knowledge of Mollie: Dr Peter Rohde for his support and advice and to Anne and Tim Hockridge for sharing Arthur's (Anne's father's) side of the story.

We were given Julian Huxley-Parlour's name by Chris Beetles of Chris Beetles Ltd, London as the right man to photograph the diaries and we thank them for their contribution. Julian's excellent work is evident in the publication.

Thanks are due also to Eugene Rae, Principal Librarian together with Sarah Strong, Archivist at the Royal Geographical Society with IBG for encouragement and for suggesting we contact the Trotamundas Press. Dr John Clarke, Curator, Tibetan and Himalayan Collection at the Victoria and Albert Museum, London was enthusiastic about the quality of the images in the diary he was shown and also gave helpful advice.

Finally our thanks are due to Mercedes Lopez-Tomlinson of Trotamundas Press for enabling our Aunt's unique diary and paintings to be enjoyed by the wider world.

MOLLIE MOLESWORTH (1907-1935)

On 1 October, 1935 Mollie Molesworth was married to Arthur Iliff at the Anglican church in Peshawar. She was 28 and he was 27. Arthur was a missionary surgeon-doctor serving with the Church Missionary Society (CMS) in the North-West frontier of India, in that mountainous border territory where Afghanistan, Pakistan, and India confront each other today.

After their wedding reception Mollie and Arthur set off on their honeymoon with Arthur driving his car. On their return journey ten days later a tyre blew. Arthur was thrown out of the car and suffered minor injuries, but Mollie was trapped inside and seriously injured. She died on 11 October. That tragic accident ended a far-too-short life in which much had already been accomplished and of which so much more was expected.

The appeal of India

Mollie was fascinated by India. She was born there and spent her childhood there. India attracted her back twice as an adult – and it was where she died. Since she died so young her story feels unfinished. We only know fragments of what she did achieve. Her baptism and wedding certificates have survived along with a few salient facts, some eyewitness accounts, and an anecdote or two.

Fortunately her art supplements her story. Enough paintings by Mollie have survived - and some Christmas cards and other graphic work - to give us a true sense of her great skill as a painter. There are also some sketchbooks of hers, which show her drawing skill, and above all there is her Ladakh diary.

There are two versions of her illustrated diary which she calls her 'notes and drawings'. It describes an expedition she made with her uncle in 1929 from Srinagar to Leh, the capital of Ladakh, and back again.

It is that diary, in facsimile form, which is the subject of this book. Our hope is that it will excite and thrill today's readers and would-be travellers as much as it has those who have already enjoyed it. 'A Ladhaki Diary' brings us Mollie Molesworth on top form not just as an artist but also as a writer.

Her early years: born and brought up in India

Mollie Rosalie Molesworth was born in Bangalore, Southern India on March 11, 1907 to Hilda Rosalie (née Brownlow) and Ernest Kerr Molesworth. Both her parents had Anglo-Irish blood and connections. Brought up in a Christian home, she was baptised on 8 May in St. John's church. Her faith was to play a consistently firm part in her life.

Her father was a Captain in the Royal Engineers (RE). There was a tradition in his family of service in the army: Ernest's younger brother Frank was also an officer in the RE. They were related to Sir Guilford Molesworth, the author of a standard pocket book on engineering. Ernest and Frank were close, and years later Frank was to invite Mollie to do a trek with him.

In 1903-1904 Ernest took part in the Tibet expedition and in 1911 he was selected to help arrange the Delhi Durbar. This gathering of India's rulers and peoples enabled the newly crowned George V, King of England, and Queen Mary to meet those over whom he was Emperor in an impressive ceremony. Today the site is deserted save for a statue of George V towering over a scattering of smaller ones.

Mollie spent her childhood years in Southern India with her parents. Her brother David was born in Bangalore on 10 February, 1913. Some time after that the family returned to England and settled in Painswick near Cheltenham, and when the first World War broke out her father was sent to fight in France. At the end of 1914 Ernest Molesworth died. Mollie was seven and David twenty-two months when their father's death was announced.

We can only guess what a setback and loss that was to his wife and their young children. After four years in the Junior School at The Cheltenham Ladies' College, Mollie was educated privately by one or more governesses. Home became South Lodge, Hoddesdon in Hertfordshire, thanks to the kindness of Hilda's friends.

Finding her life's work

Mollie grew up as a lively, likeable, healthy and active young person who enjoyed life and the leisure her circumstances provided. The family had annual holidays in Devon and Brittany with their cousins and there are sketches and photos of this, and of her skiing. She also, we think, visited Ireland and family in Scotland. She had a close relationship with her mother.

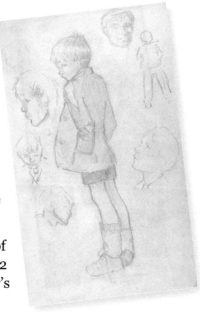

Her first cousin Beatrix, eldest of her Uncle Frank's three children, remembers Mollie as tall and slender with long, neat mousy brown hair, which she tied in plaits on top of her head. She was calm by temperament and had a rather delicate, Pre-Raphaelite face.

She applied to, and was given a place at, Wimbledon School of Art. She studied there from 1925 –1928, living in term-time at 12 Denmark Avenue, Wimbledon with her 'aunt' Lot, her mother's friend.

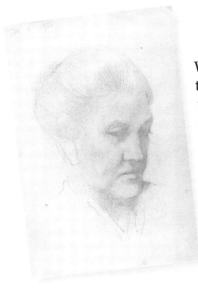

Mollie was a talented student and completed her studies at Wimbledon in the summer of 1928 at the age of 21. She applied to the Royal College of Art (RCA) and was awarded a scholarship. At this time her uncle Frank and his wife Eileen invited her to India. She was torn: should she accept their invitation or continue her training? She contacted the RCA, who having seen her portfolio, judged her proficiency was such that she would gain more working from life in India than from academic study in London, and agreed to defer her place for a year.

There are very revealing and delightful sketch books from her art school days. The earliest surviving one is Vol: III dating from 10 July, 1925 when she was 18. (This suggests she had been keeping a sketch book well before going to art school.) The existing sketchbooks contain pencil drawings, small water colour sketches, notes from lectures and anatomy details, and both drawings and coloured sketches identified as 'Memory' work. She loved drawing horses and was to depict Ladakhi polo ponies in her diary. Cats, dogs, sheep, pigs, geese & zoo animals also feature in her sketchbooks.

She could catch a likeness of a young person or adult. There is a very fine drawing of her mother dated 16 January, 1926. She also drew her young brother David. One drawing has him standing with his hands in his jacket pockets, a look of Just William about him. Another drawing shows him as a twelve or thirteen year old with a bandage round his head, after a fall down a cliff.

Returning to India

On her arrival in India in 1928 Mollie was based with her uncle and aunt, Frank and Eileen Molesworth, in Rawalpindi in the Punjab area of Pakistan. After Ernest's death Eileen and Frank had helped to support Hilda and her two children.

Frank's diary and Eileen's letters to their daughter Beatrix describe Mollie's lifestyle at that time, which included playing tennis, riding, picnicking, socialising, church services, and skiing. When possible Eileen and Mollie would go off and sketch. Mollie also taught painting and drawing. One of her pupils was M.M.Kaye who was later to write 'The Far Pavilions'. Frank organised expeditions which took the three of them up to Peshawar and then to the Khyber Pass from where they looked down on Afghanistan. Such travel was not easy. The roads on the North-West Frontier were variable and sometimes made awful by the weather.

Mollie travelled extensively during her time in India, alone or with Frank and Eileen. Place names are given as today's equivalent. She restricted herself largely to northern India, especially the north-west. For the first seven months of 1929 she was in the North Western states, visiting Peshawar and the Khyber Pass, Kashmir and Jammu (which today includes Ladakh). She also visited Jodhpur, Attok, Jhelum, and the Taj Mahal, and she exhibited in Shimla and Mumbai (Bombay). Where possible she sketched and painted. She was awarded a silver medal and other prizes. She held two solo exhibitions, one in Frank's drawing-room on the afternoon of 15 March, 1929.

But Frank and she had planned a very special journey which would be a first for both of them. As Mollie put it, 'In the spring of 1929 my uncle and I set our hearts on an expedition to Ladakh.' Ladakh or Little Tibet was a largely Buddhist state normally closed to travellers. But it was opened in the summer months to a few visitors with special permits.

For Frank this expedition to Leh was the realisation of an ambition: before he left India he wanted to see Ladakh. Twenty-seven of his twenty-nine years of service had been spent in India. He had reached the rank of Lieutenant-Colonel and on 16 March, 1929 his official retirement had begun. While he prepared to leave the army, Eileen and their third child, Stephen, left Rawalpindi by train and took a ship back to England. Meanwhile Mollie went on ahead to Srinagar to await her uncle, staying on Lake Dal. Frank sold their unwanted furniture, handed over his house to his successor, attended good-bye events and dinners, and then set off on foot to travel the 100 miles of so to Srinagar which he reached on 6 May, fourteen days later.

By the time he joined Mollie in Srinagar he was a civilian. His solo walk had made him even fitter, and all that remained for them to do was to assemble the necessary stores and do some sightseeing and socialising until they could collect their precious permits. For him their joint adventure marked the end of an era and his goodbye to India, which he left soon after their return from Ladakh. On his last night aboard ship he won a limerick competition and received a cigarette holder as a prize. His acceptance speech was in doggerel. Mollie was to draw on his poetic skills and humour in her Ladakhi diary.

Given her first London solo exhibition

After her Ladakhi trek and her uncle's departure, Mollie stayed in India for a few more months. She reached London on 14 December, 1929, having brought back an impressive portfolio. She was offered an exhibition the following October in Walker's Galleries, a prestigious venue, at 118, New Bond Street, London. She was twenty-three.

Mr. R. Hamilton, reviewing her water-colours of Kashmir, Ladakh and Northern India for the galleries' in-house magazine, recognised that 'travellers and explorers, with their stories and pictures of strange lands, have always had great attraction for humanity.' In Mollie Molesworth he found a rare combination of 'the joyous spirit of adventure and the cheerful acceptance of physical hardships which are the marks of the pioneer and explorer, allied...with high artistic achievement.' Her pioneering was in places that other artists had ignored or which had rarely, if ever, been painted.

Hamilton noted 'a varied range' of both 'subject and setting' in her paintings. Her subjects included the 'snow peaks of the Himalayas towering above the luxuriant meadows and fields of the Jhelum valley; gay, lively scenes in Punjab bazaars; enchanting glimpses of ancient architecture in Jodhpur and Bikanir; and visions of the monasteries of Ladakh hanging from the precipices of which they seem part.' He admired also the varied weather depicted: 'the clear sparkling sunshine of a North Indian winter', 'the misty softness of the Vale of Kashmir in the rainy season', and 'the thin transparent air of Central Asia'.

'The Times' printed an anonymous review, a little condescending in tone, in which the writer agreed with Hamilton that Mollie had 'penetrated adventurously into distant and difficult lands to find her subjects', and liked the 'extreme simplicity' of her treatment and admired her skill in depicting the East:

'It is comforting to those who have never seen the East, but have feared that it could never come up to the illustrations of the Arabian Nights which they knew in their childhood, to know that the East is exactly like this. Here are the brightly coloured bazaars, the fantastic and unstable buildings, and the inhabitants who are certainly not, as the tourist would put it, natives, but close relations of Ali Baba.'

Her reviewer, however, rightly recognised Mollie's illustrative skills and felt she had adapted her technique to match that of the Arabian Nights illustrators', and noted that 'nearly all her pictures are perfectly flat, and bright and decorative in colour' so that her work 'fitly' represents the East.

We do not know how many works Mollie showed in that exhibition. But Frank in his diary recorded that she had sold 11 paintings by 3.0 p.m. on the first day, and that four days later she had sold another 7, and so covered her expenses. When the exhibition ended she had sold 31 paintings for a total price of £280 – an average of £9 a painting. We do not know whether or not she displayed her diary on that occasion but she may well have talked about her trek. For Hamilton seems to know about the extreme cold that she and Frank had faced (see her entry for 23 June) and the number of 'marching days', and other details.

Mollie's 'A Ladakhi Diary'

Mollie and Frank left Srinagar in Kashmir on their big adventure on 22 May together with servants and 10 ponies to carry their tents and baggage. They reached Leh, the capital of Ladakh on 10 June, having travelled 250 miles in 17 'marching days'. They rested there and were shown round by Bishop Peter of the Moravian Church. Then they made two further journeys, one to the Buddhist monastery at Hemis where the annual festival was being celebrated, and the other north and upwards into the Himalayas to the Khardong Pass. Here both the altitude - at 15,500 feet they were at the highest they had ever been - and the cold defeated them. Back again in Leh (19-21 June) Mollie 'sketched at every opportunity' watched by a crowd of local 'urchins'.

Uncle and niece set off from Leh to return to Srinagar on 25 June, made better time, and arrived there on 10 July, having, in Mollie's words, 'covered 560 miles in 50 days, 36 of which were marching.' Frank then shaved off his 'very fine beard', with which, Mollie thought, he hoped 'to be mistaken for Zeus'; and he also paid their outstanding bills which amounted to 936 rupees (or 70 pounds and 4 shillings in British currency).

Mollie's enthralling diary provides an excellent example of her pictorial and narrative skills. She used charcoal drawing paper from a Winsor & Newton sketchbook for the text and illustrations. Of the two versions that she made it is the second which is published in full. For it was prepared from the first. But each version has illustrations which are unique, and some from her first version are of such merit that they are included in a pictorial supplement.

Mollie had an eye for all the necessary details in the depiction of a person's character and costume (27 May) and yet she concisely caught the essence of a day. Frank and she shared a sense of humour. The poem about yaks (see also 27 May), which Frank had previously made up, was published in 'The Times of India' on 13 January, 1929 together with an ink drawing of Mollie's, under the heading 'Topical Rhymes'. Mollie also includes a limerick of Frank's (1 July).

She had, at times, to find considerable reserves of courage. She underplays the difficulties and dangers they faced: for instance when crossing a ravine on the trunk of a poplar (9 June). But she admits – in her photo album - that they crossed the bridge at Dras, which consisted of three twisted willow twigs, 'at considerable peril' (28 May). Her diary and her visual record of the trek, made when she was 22 and Frank 49, invite us to see Mollie as a rounded, balanced and alert human being, of whom any family would be proud.

A first edition

If she hoped the diary would be published in her lifetime, she was disappointed. This is the first ever edition. Much thought has gone into the way she portrays both the trip and herself. For instance, a draft text in pencil can be seen under her inked writing and there were often three stages to an illustration: first the pencil drawing, then the picture made with water colour, and finally she might add black ink for emphasis. Her compositional skills were outstanding: she knew what to include and how to arrange her picture.

She features herself three times in her final version: first scrambling along the poplar over the chasm with Frank following behind her (9 June); then when chained mastiffs threatened to bite her legs (16 June); and finally resisting the Skushok's request for her painting (17 June). In her first version of the trip she also included a picture of herself gingerly approaching water for a bathe.

The Hemis festival, a major Buddhist event, engrossed her and received the greatest coverage of words and paintings. She describes the sequence of music and dancing stage by stage. To her the long-running spectacle, described by one commentator as a mystery play, with its timeless drama and dancing, massed musicians with unusual instruments, masques and weird performers, was captivating and had to be painted. She also took photos which in turn helped her with the composition of her pictures.

In contrast Frank's diary account of their trek is more factual – he dutifully records the stages of each day's walk, the daily mileage and the changes in weather. His reporting is a little dry, restrained, and laconic. But he seems to need other people's company more than Mollie: he is more likely to mention when they happen to meet others. On 2 June after completing their day's stretch of 23 miles he records that they were given tea by Mrs. Ferriday. In Mollie's entry for that day she reckoned they had gone 24 miles and she does not mention the Ferridays: she prefers to muse about the local custom of a woman marrying a family of brothers.

Occasionally Frank's feelings for the countryside break through lyrically. On 25 May they left Gund and travelled through muddy and wilder countryside until after about 8 miles:

> 'we entered the finest scenery I have ever struck. The Sind (river) below, forest around, on the right forest stretching up to snowy mountains whose tops were in cloud and on the left terrific cliffs.'

When they finally left the trees that day and had crossed the river, the going was flat thereafter until Sonamarg, their destination. Two days later they set off at 7.15 a.m. to ascend the Zoji La pass. At about 10.00 they reached the summit and a height of 11,578 feet. There Frank notes: 'weather perfect but for a cold wind in our faces. Enormous mountains all round and the firmament the colour of terrible crystal.'

But Frank's dairy also tells us additional things: that he hurt his back when he fell off a pony (3 June) and that he and Mollie did not always walk: on June 10 they shared a pony; that he left his keys behind (5 June); that he had some revolver practice (5 July); and that Mollie suffered from a fever just after the trek was completed (14-15 July).

Painting in Labrador

Mollie's love of travel took her to far-flung places in search of adventure and subjects to paint. By May 1931 Mollie was in Labrador as a volunteer to help the work of the International Grenfell Mission (IGA). These volunteers were known as 'wops', which stood for workers without pay. They were willing to do any jobs although they might have no particular skills. Mollie stayed a year and was based in St. Anthony in Newfoundland. She proved an exceptional wop, using her artistic skills to full advantage.

Dr. Wilfred Grenfell had founded his mission in 1912 to establish and improve medical, educational, and economic facilities in the Great Northern Peninsular and Labrador. In time the IGA maintained hospitals, nursing stations, medical steamers, boarding schools and an orphanage. Grenfell also realised that the ordinary people needed more opportunities for employment, and so he set up projects for the teaching of arts and crafts, for agriculture and tourism.

Mollie balanced her time in Labrador between making her watercolours (for sale) and actually being a volunteer. Her 1931 sketchbook includes landscapes, local people, groups of children, the lady mayor of one settlement, and drawings and pictures of boats. Her watercolours sold well with the missionaries, and this money funded her voluntary activities. For a time she was in charge of St. Anthony's newly established Community Centre and she spent three months in Nain, an upcountry settlement. Rhoda Dawson, a fellow wop and artist, confirms that Mollie was popular and adventurous: 'Still, she has walked across the Himalayas and tramped through Thibet.'[1]

Mollie travelled, painted and paid her way. She met Grenfell, who signed her sketchbook and drew two humorous ink cartoons with captions.

Later, when Grenfell was writing his autobiography in 1932 and describing the work of the wops, he was surely referring to Mollie in this anonymous tribute: 'Another young lady ...financed the help she is giving... by selling her charming paintings. She managed even in these days of depression... to sell enough to enable her to give us a year's voluntary service.'

As well as painting water colours Mollie also designed Christmas and other cards to raise money for the mission work. Her Labradorean paintings reveal great expertise. She was brilliant at painting snow and ice and at bringing the coast, its people, their low wooden homes, and the mountains behind, alive for us today.

Mollie, we think, went to Labrador because her brother David told her about it. He had been personally recruited by Grenfell when the latter visited his school in Norfolk. David first went to Labrador in 1931, probably as an undergraduate, and again in the summer of 1932 (when he also sailed to Iceland).

1 From Paula Laverty, *Silk Stocking Mats: Hooked Mats of the Grenfell Mission*. Montreal and Kingston: McGill-Queen's University Press, 2005. A bit of an exaggeration but Rhoda's remark shows how Mollie's travels in India had given her the reputation of an adventurous traveller.

He was not afraid to tease his elder sister. Back in Hoddesdon once more, he was with her when she asked her cousin Beatrix to do her a favour by helping with the local Sunday school which she ran. 'Watch out when Mollie asks a favour,' warned David. Beatrix's heart sank at this request but she bravely had a go.

After Mollie and Arthur Iliff were engaged, they went to stay with Beatrix's parents, Frank and Eileen. Mollie shared Beatrix's room. Beatrix remembers picnics on the beaches near Bideford, and Arthur driving an old banger called Boanerges, and his being very good with children. Arthur and Mollie also went skiing in Europe.

When Arthur qualified as a doctor, he was employed by the Church Missionary Society and expected to be sent to either Persia or Northern India. In 1934 he was posted to the latter and was based in Quetta. Soon after he had arrived the area suffered a severe earthquake and Arthur found himself at the heart of the catastrophe doing what he could to help the injured. One consequence of the earthquake was that he adopted a stray dog, 'Brigadier', whose owners had disappeared.

In 1935 Mollie went out to join him. In his memoir Arthur recalled the 'great change' in his life that resulted from her coming:

> When I had come out to India some 12 months before, I had left behind in England my fiancée, a girl who not only shared my Christian beliefs but was willing to tackle the undoubted hardships of a missionary's wife in India. Just a few months older than I, she had already achieved a wide reputation as a painter. She knew India well, for her parents had spent many years there in Army service... She had also travelled extensively, accompanying her uncle (also an RE officer) on a long trek which gave her unique opportunities to portray on canvas places and scenes in India and Tibet which few have occasion to see...

> Our wedding, on a lovely Autumn day in Peshawar took place in the old Mogul fortress which over the years had been transformed into the chapel of this mission hospital on India's NW Frontier. It could not have been a happier occasion for both of us for, despite the absence of so many of our friends and relations in England, our new friends in India overwhelmed us with kindness. When finally we got away on the road to Kashmir and our honeymoon in an old Chevrolet car I had acquired, we anticipated a quick run through. We soon had trouble with the tyres, one of which had burst and had to be replaced. Yet another was repaired in Kashmir.

> On the second day of our long road journey back to Peshawar in the plains, ten days later, another tyre burst at speed. The car was thrown into a violent skid and then did a complete somersault before coming to rest. Thrown out on to the road I escaped with minor injuries, as did our Indian bearer and my dog Brigadier. But it was a different matter with Mollie. Trapped in the badly damaged car, she had suffered severe internal injuries and was in deep shock. The nearest hospital was equipped with few facilities and though help got through from Peshawar in a few hours, she died early the next morning.

> One never knows until it actually happens how one will react to disaster and catastrophe. The earthquake in Quetta, overwhelming in its effects and frightening in

its intensity, had nevertheless provided me with a challenge, the more so in my capacity as a doctor. There had been work to be done, needs to be met. One was almost too busy and involved to realise how utterly destructive it had been. Human sorrow and suffering was all around but had not touched me closely enough to affect me too deeply.

But here was something different: a personal tragedy which was to influence my whole life; a disaster big enough to threaten my faith. To begin with I felt stunned by the intensity of my grief and sorrow. Indeed when the lorry carrying the coffin containing the body of my wife back the 100 miles or so to Peshawar skidded on a wet road and nearly overturned, I found myself praying for a similar and much more serious accident to follow quickly if possible, if only so that I might follow her in spirit. I was devastated yet not suicidal.

Once again, as in Quetta at that moment of loneliness just after the earthquake, I felt a Presence with me. He was there, the One I served. And though I felt as if I had entered a tunnel in which no glimmer of light could be seen, I knew there was someone by my side, guiding my steps.

News of the accident reached England and an obituary of Dr. Arthur Iliff mistakenly appeared in *The Times* on 17 October, 1935 but there was not one of Mollie.

Postscripts

In 1942 David Molesworth, Mollie's brother, by then a doctor and married, was serving in Malaya. The Japanese invasion of the north caused an exodus of people to the south, mostly to Singapore. His wife Rosemary left their home first and drove to Singapore with their daughter Jenifer. Then he had to flee, being forced to leave everything but their clothes and Mollie's pictures.

Later in Singapore Rosemary managed to get herself and Jenifer safely on the last boat to leave Singapore before the Japanese reached the city. She must have taken those pictures of Mollie's with her to England.

For, after the war, in 1948 there was an exhibition of paintings of Labrador at the Alpine Club Gallery, London. Among the artists represented were Rhoda Dawson and Mollie Molesworth. David was very pleased to lend some of his late sister's paintings, including perhaps some of the paintings that had been saved from Malaya. Queen Mary visited the exhibition which raised £180 for the IGA.

Arthur Iliff married again in 1941. His bride was Vera Cox, a CMS missionary doctor's daughter from Peshawar, who was a good friend of Mollie's. Arthur and Vera had three children, the youngest of whom was Anne. When Anne and Tim Hockridge were engaged and planning to drive his car on their honeymoon, Arthur was concerned about the poor state of its tyres. He insisted to Anne that they must be changed for better ones.

When he learnt that they had done this, he admitted regretting not replacing his tyres before he set off on his first honeymoon. 'I just did not have the money', he told Anne. 'But then, if I had, perhaps you would not be here now!'

Mollie portrays the King and Queen of Ladakh in her diary. Eighty years later with my wife Sheila, Mollie's other niece, we followed the route of her trek by road (which had not been there in 1929). We took with us a photocopy of the diary and prints of its illustrations. These we shared both with our hosts and the people we met. At Leh our guide arranged for us to have an audience with the present King to whom Sheila showed the copy of the diary. He was very interested and asked for a copy of the whole diary for the national cultural archive which he had established.

We also let the headmaster of the Moravian School in Leh look at the diary. He too was thrilled by it, and also asked for a copy for his school archive. Back in England we sent both of them a photocopy.

Mollie's paintings gave great pleasure to those who saw them during her lifetime. They are cherished by their owners today. It was clear from our conversations with both Kashmiris and Ladhakis that they have not seen anything quite like Mollie's recording of their peoples and land. We very much hope that one day - soon - an edition of her diary may be available to them as well as to the peoples of Europe and North America.

Jeremy Harvey

DIARY 1

A LADAKHI DIARY

In the spring of 1929, my uncle and I set our hearts on an expedition to Ladakh.

A limited number of permits are issued annually by the Kashmir Government, + we were fortunate enough to obtain two of these.

The following notes + drawings were collected as we journeyed.

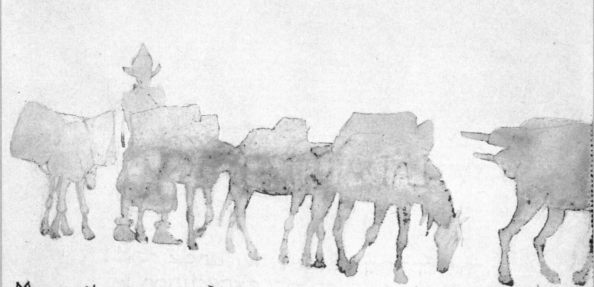

May 22ⁿᵈ 1929

**Srinagar
to
Ganderbal**

13 miles

A glorious day. We started from Srinagar at 9 a.m and reached Ganderbal in the afternoon, waiting some time for the baggage which was coming by boat. As we waited a barber came up + asked to cut my Uncle's hair, adding that it was very long. He nearly found a watery grave.
No more barbers up to date.
Here the Sind river comes tumbling down from the hills, full of melting snows. + the rice fields are all flooded + reflect the mountains round.

**May 23ʳᵈ
Ganderbal
Kangan**

12 m.

The lambadar provided 13 ponies to take 16 maunds of baggage (the authorized load being 2½ maunds) After a lengthy argument we reduced the number of ponies to ten.
The march was chiefly through rice fields, built in steps as the valley became steeper. Two hopeful peasants asked us to come + help them fight off bears, + the Dāk Bungalow was full of flies.
The first patient arrived suffering for the last 6 months from perpetual tummy-ache. Remedy prescribed — epsom salts to be taken tomorrow morning, after we have gone!

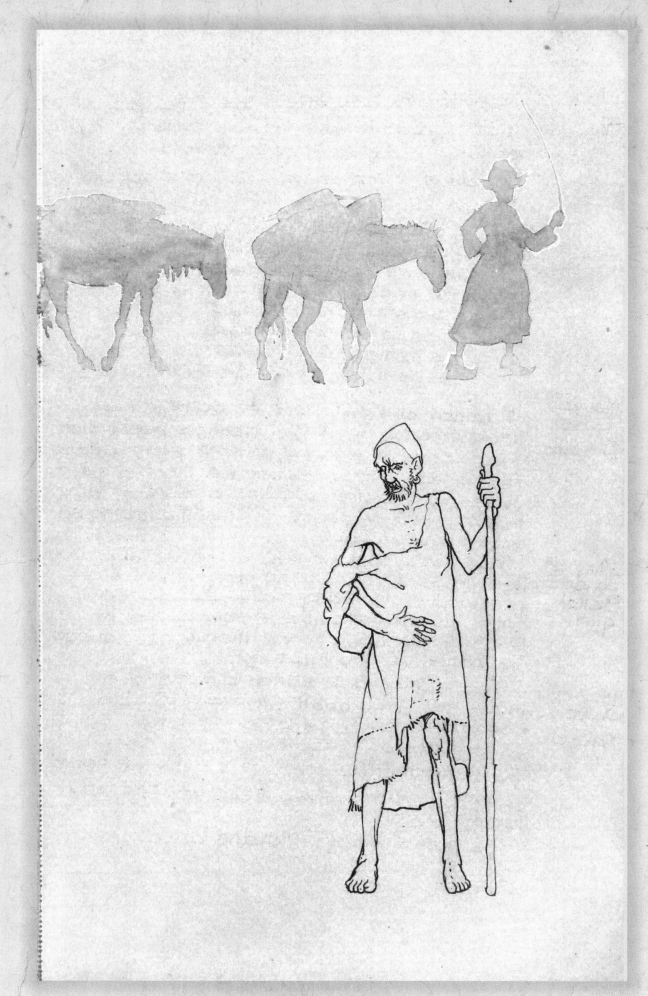

May 24th
Kangan
Gund
14 m.

A terribly muddy march as it rained all night: &, a dark dāk bungalow probably full of fleas. &, our Keatings is mislaid - Ladakhis & their dzoes occupy the adjoining serai.

> I'd like to draw the leg & toe
> And profile of the gentle dzoe.
> He always seems so full of woe
> The mild-eyed melancholy dzoe.
> I am afraid he worries so
> Upon the fact he is a dzoe:
> His mother was a buffalo
> His pa a yak, & thats the dzoe.

May 25th
Gund
Sonamarg
m

It rained all the way but the scenery was magnificent. About 1½ m from our destination we came onto the 'marg', an open grassy space. As we were soaked we were very glad to get to the serai & steam ourselves at a fire, also the march was our longest yet, & stiff climbing so we were very tired.

May 26th
Sonamarg
Baltal
9 m.

Short march, fine weather, wonderful view - Rest-house in a delightful birch wood full of primulae. We heard avalanches crashing down neighbouring hills, & saw a few flying rocks, which however we managed to dodge. The Zogi-la confronts us grimly.

May 27th
Baltal
Matayan
Th 18 m

Two human ants started climbing an enormous hill. At 11,000 ft we passed the last birches & soon after that came to the snow line. Trying going. Glorious day but a bitter wind. The summit of the pass is 11,578 & we heard a cuckoo above us. They must be fairly hardy birds. Also met several caravans of yak :-

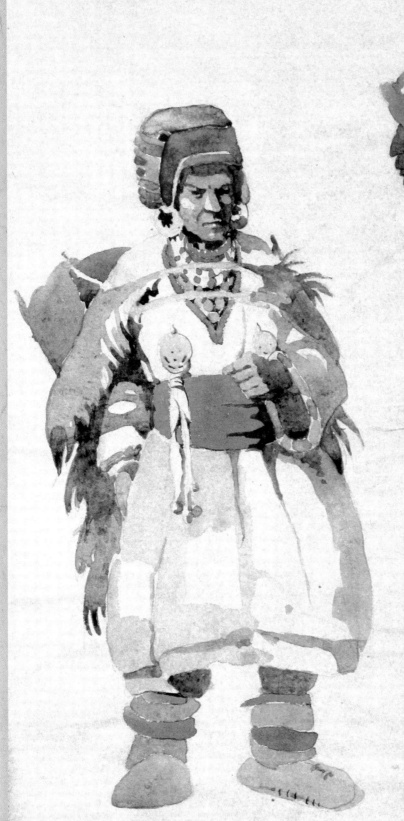

Dras ladies

17

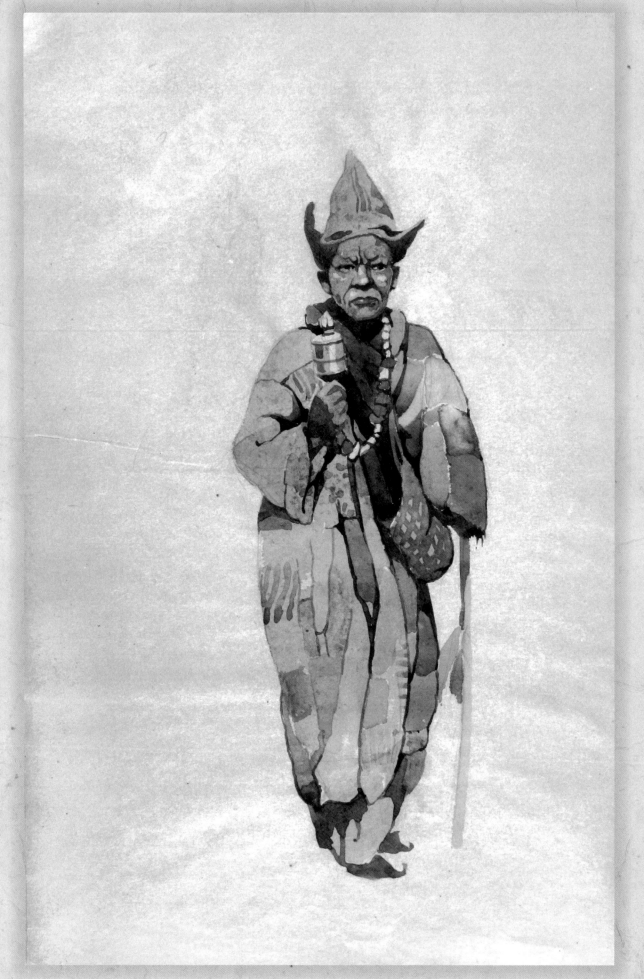

I'd like to draw the face & bak
And forelegs of the mighty yak
My bungalow shall never lak
For pictures of the mighty yak.
And, now I've fairly got the knak
I'll tell you more about the yak -
His hair is red, his face is blak
His nose is pink, the mighty yak
Upon the Zoqi's snowy trak
We met a caravan of yak
And here's the very final quak
Now that I've really seen a yak
HE DOES NOT MAKE A USEFUL HAK
He's much too slak the lazy yak
You have to whak & beat his bak
To make him move the laggard yak

As we descended the snow got worse & worse.
We passed under Machoi glacier & found the
serai but as the coolies wanted to go on, we
rested an hour & then tackled the next stage.
The snow was now soft & very heavy; there were
wonderful primulae by the streams.
Reached Matayan 4·45 p.m, march of 15 m. by
map, 18 by mile stones, & 38 by our own feelings.
Got terribly blistered by glare & sun, but felt
better after a colossal tea.
 Two patients – one of our coolies who had fallen
& cut his face rather badly, & one who we did
not see, a lady – on whose head according
to her husband a mountain had fallen. As
his Urdu was a bit weak we think he was
muddling 'Pahar' mountain, with 'Pathar' a stone.

May 28th Terribly cold to start with, ice on all the
Matayan puddles formed by melting snow. Later as
Dras the sun rose we warmed up. Descended
12 m the valley of the Gomru river, covered with a
 variety of yellow tulip. Reached Dras 12·20.
Natives beg us for matches, a great luxury here.
 Near Dras is a bridge composed of 3 cables

14

of twisted willow twigs. You walk on one, hold onto the other two, & pray hard.

Feeding has its horrors! The only meat ob-tainable is the toughest chicken known to history whose remains the cook curries lavishly.

No fruit or vegetables are to be got, & beef in any form of course, is forbidden from Kashmir.

May 30th
Dras
Kharbu
20 m

A pretty stiff march as the track was covered with loose stones & very steep in places. We reached Kharbu with skinned knees & broken sandals, & found an english couple in the serai. We willed them hard to give us some tea - a most successful effort! We haven't seen a paper of course, so we all wonder how the General Election is going.

May 31st
Kharbu
Kargil
16 m

Rather trying, as the streams marked on the map seemed to have vanished, so we got no water till the 15th mile, & the day was hot & the way full of soft, hot sand. Kargil is quite a big place, the headquarters of a tehsil, but the serai is in an arid waste where the wilderness fairly howls. Trade routes also meet here, so there are all sorts of funny people about. Stayed here one day.

June 2nd
Kargil
Mulbekh
24 m

A long shadeless march of 9½ hrs. but interesting as we are now definitely in Buddhist territory. Gompas & chortens abound Gompas are monasteries generally perched on the top of some crag; chortens contain 'potted lamas' & other holy relics. You must go round a chorten with the sun, or you will be torn in pieces by ghouls & dragons. Ladakhis, however are very polite, so we feel sure the local demons wouldn't tear Britishers to bits, who sometimes take the shorter way.

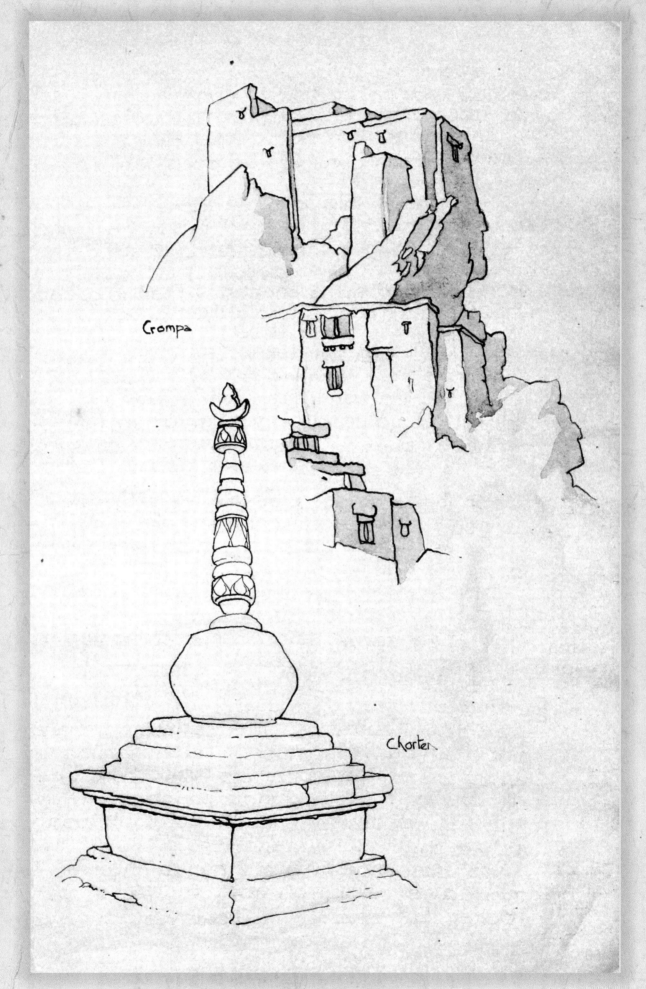

Grompa

Chorten

In this country polyandry is the rule. i.e. a woman marries a family of brothers.
We thought proposals must be rather complicated, perhaps something like this –
They. 'Jemima will you be ours. will you marry us?'
She. 'oh but this is so sudden; besides you know my parents want me to marry the Smiths.'
They. 'That lot! Why Alf has actually been known to wash twice a year. Bert went the wrong way round a chorten. & Fred is a boy whose pigtail can't be more than a yard long. You can't prefer them to us!'
She 'Well then you know you were seen winking at the Jones girl the other day.'
They. 'No, that isn't true; what happened was three flies got in our eyes just as we met her.'
She. 'Well maybe, but anyway I shall have to ask my fathers & mother.'

June 3rd
Mulbekh
Bod
Kharbu
16 m

On this day we crossed the Namykala 12,500 ft. It was very steep & stony, & my Uncle fell & hurt his back, which necessitated a day's halt.

June 5th
Kharbu
Lama-
-yuru
15 m

Rather strenuous day including climbing the Fotila 13,500 ft. We caught a distant view of the snowy range beyond the Indus. Descended into unutterably bleak country but suddenly came on cultivation round Lamayuru. This village is a huge pile of gom-pas & other buildings whose situation reminded one of an official manual on bush fighting which began 'Certain jungle tribes build their villages on the tops of inaccessable mountains'
My Uncle left the keys at the previous camp so we could only wash & sleep.

June 6th
Lama-
-yuru
Kalatse
9 m.

We descended into a weird ravine with mountains rising on both sides in un-believable shapes. Dore would have

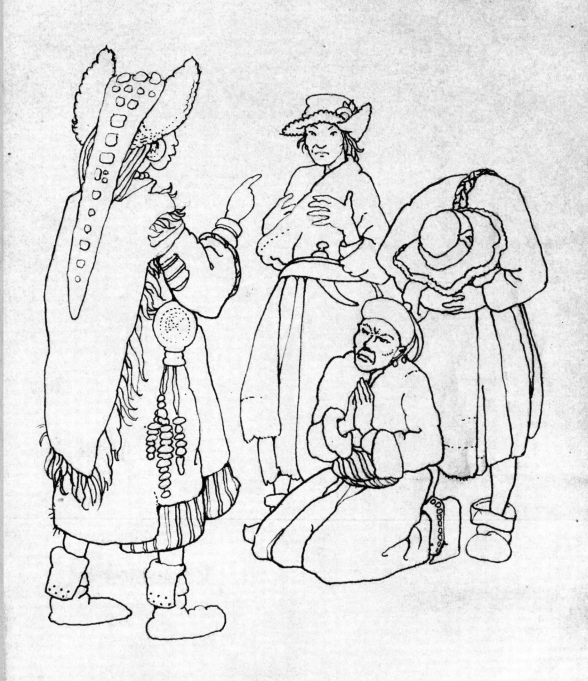

loved it, & we quite expected to meet
Apollyon 'straddling quite across the way'
After 7 miles we got to the Indus, which was
a deep copper colour, & its valley uncomfortably
hot. We crossed it by a suspension bridge
the end of which led into an old fort.
Kalatse sports a Post Office run by a Tibetan
more like a djinn than a human being:
& another building the outside of which was
being labelled TELEGRFOFICE by a similar
djinn who told us he was only staying
there till he'd married off his five daughters!

June 7th
Kalatse
Nurla
9 · m

 A shortish march & we actually found
ourselves at the end before we expected it.
A most unusual experience.
The hills are all shades of brown & pink
& the snow on the tops looks like icing sugar

June 8th
Nurla
Saspul
14½ m

In the evening, attracted by the sound of drumming
we went to a neighbouring gompa & found
a strange show. About 50 men were sitting
eating a meal of grain & milk to the occasional
accompaniment of drum & fife band of 8 men
& 1 woman. They did not mind us looking,
or me sketching, so I stayed later & saw
a stately scarf-dance executed by two
enormously fat lamas. A humerous sight!

June 9th
Saspul
Nimu
13 m

 We started wrong owing to the map
not being up to date. We had a fearful
scramble & had to cross a chasm on the stem
of a poplar tree, but
found the track at last
which led us over a
pass, & then a series
of sandy plains. We
saw several ibex.

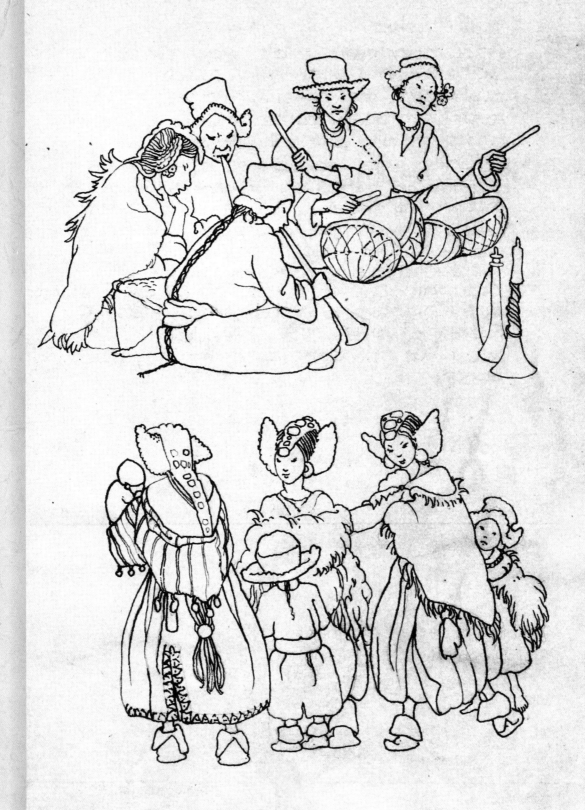

June 10ᵗʰ We first negotiated a pass. Then came
Nimu to a series of open sandy stretches, merci-
 fully broken by two good streams.
LEH) After rounding Spitok we saw Leh in the
19m distance, but even after reaching the
 cultivation round it, we had a weary
 march through lanes & waterways (they
 are generally one & the same)
 Entering what looked like a stable door
 we found ourselves unexpectedly in the
 main street of Leh, with a row of poplars on
 one side, & in front a huge gompa on an
 inaccessable crag.
 We found a nice Rest-house, the other
 occupants of which are the Shyok Glacier
 party held up as the Khardong Pass is
 still snowbound.
 We have now done 250 miles in 17 marching
 days.

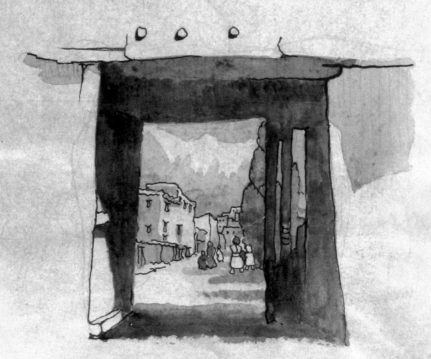

Entrance to Leh

Leh ladies

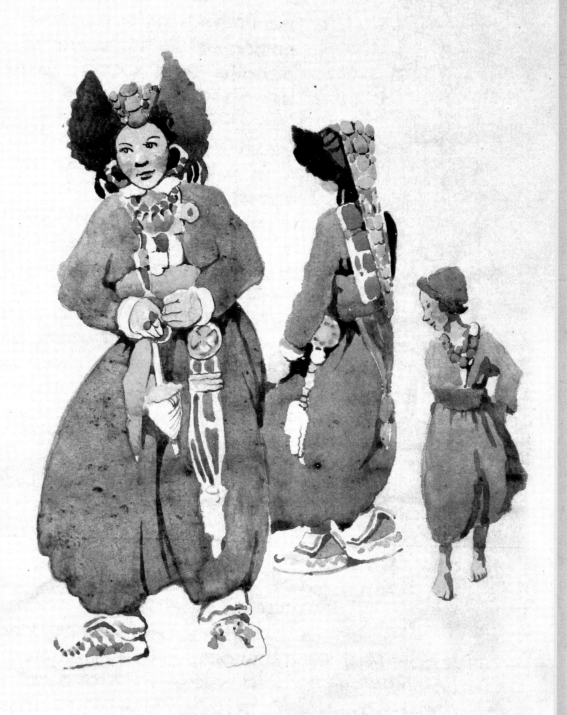

Bishop Peter of the Moravian Mission took us over three of the monasteries.

The uniform of a Moravian bishop consists of a knitted cap, decolté vest & coat, turned up shorts & chaplis.

We first went to the big gompa overlooking the main street.

It is a huge building of several stories. The lama in charge was quite friendly & thought we gained merit through the visit, which he was quite sure about when we gave him some money.

There were many sights, too many to enumerate, but we must mention a silver butter lamp, a huge bowl filled with butter with a little wick floating in the centre — it burns for a year; a huge Buddha so large that his head is adored from one story, his middle from another, & his feet from the lowest floor; & a lama with so grotesque a face that when he put on one of the devil-masks it seemed an improvement.

The Bishop who had been in Leh 30 years was an admirable cicerone.

June 11–14 Halted at Leh : I painted, my Uncle explored, read, wrote, or did nothing. The weather was cold with a lot of sleet & the snow came down very low on the neighbouring mountains.

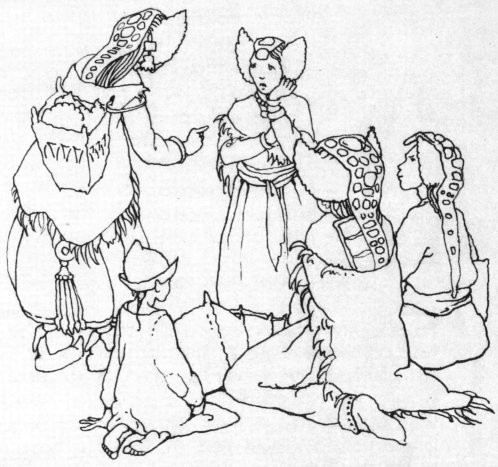

June 15th Started for Himis on ponies. Average
Leh pace 2½ m per hour, wooden saddles, stirrups
Himis all one fixed length. We went down to the
24 m Indus which we crossed by a precarious
wooden bridge. + then moved up the
valley for several miles. Delightful
parties of pilgrims were also journeying
to Himis all dressed in their best. We left the
main valley for a smaller + very narrow one, +
found Himis built into + across the head of it,
colossal crags rising behind the monastery.

Later I entered the monastery & saw a rehear-
-sal of the show

June 16th Twice in the night the monastery
orchestra made a dreadful groaning
noise. After breakfast we went up to
the gompa by devious passages
guarded by fierce chained
mastiffs, with only just room for
the calves of our legs between.
(The main entrance was blocked
with pilgrims). On the walls of
these passages were series of
prayer-wheels to which you give a twirl as you
pass, & they go on praying for you as long
as friction allows.

Entering the large courtyard used for the
play, we were led by a lama to a gallery
facing the main doorway from whence we
had an excellent view. The orchestra was below
us; other galleries, the monastery is several stories
high, & the edges of the court were crowded
with spectators in their gayest attire; & lamas
in every shade of red, magenta, brown &
purple, thronged the sides of the stairs
to the doorway.

Presently the Abbot or Skushok took his
place in the gallery next to ours. As he
crossed the yard the crowd surged forward
to kiss his footprints. A Skushok is
the re-incarnation of all previous Skushoks
since the monastery was founded. This
particular one is said to be 17.00 years old
When a Skushok dies the monks look
out among the male infants born shortly

after for his re·incarnation & seize
upon the most likely . There is always
a danger of a traveller being claimed
by a monastery as a long·lost Skushok.
My Uncle suffered agonies of apprehension
every time we passed a gompa .
The titular king of Ladakh appeared
next . His ancestors were deposed by
Sikhs shortly after the latter were con-
-quered by The British .

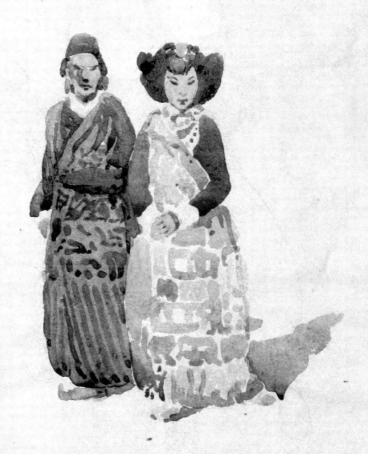

The king & Queen

Two clowns in masks & flat caps
opened the proceedings with a dance
& thereafter acted as buffoons or police-
-men as occasion demanded.

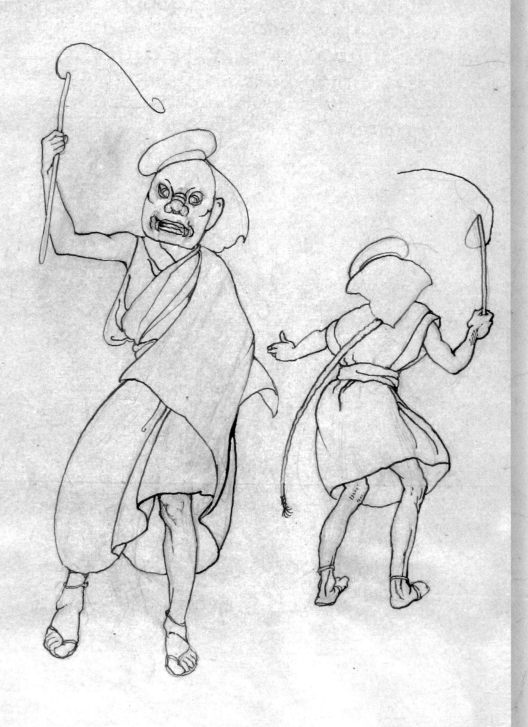

Thirteen lamas in gorgeous robes &
wide umbrella-like hats crowned with a
strange emblem next appeared, revolving
slowly round a central prayer pole.
The rhythm was so painfully slow, that one
felt the dancers must overbalance before
the next beat.

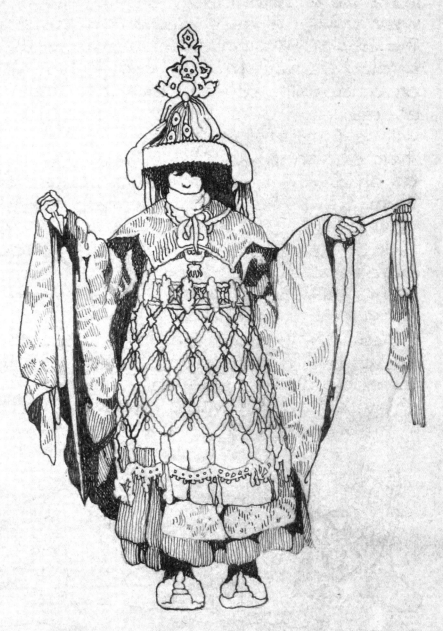

The second dance was somewhat faster. Sixteen lamas complete with drums & bells took part. The orchestra was silent but a deep Gregorian chant pro- -ceeded from somewhere.

The third was much more elaborate. There were about 30 performers, 8 of whom were gods, 16 musicians, & 4 funnymen. The gods, the greatest of whom had a canopy circled round the courtyard & then sat down on a tapestry covered bench. They wore enormous masks, blue, brown & pale-coloured with a third eye in their foreheads to show their superiority. The musicians then squatt- -ed on a strip of embroidery & played before them, while the funnymen held the stage. Next scantily clad men with large flags on their hats, & some small boys came & danced before the gods, beating drums that looked rather like frying pans. The gods then rose in turn & did a pas seul except the largest who was too fat. Buddha was said to be in this gathering, but occupied a subordinate position.

At midday the whole assembly left the stage

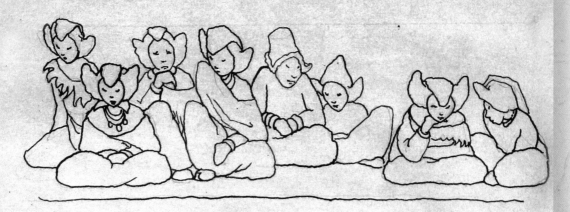

Part of the audience

Orchestra

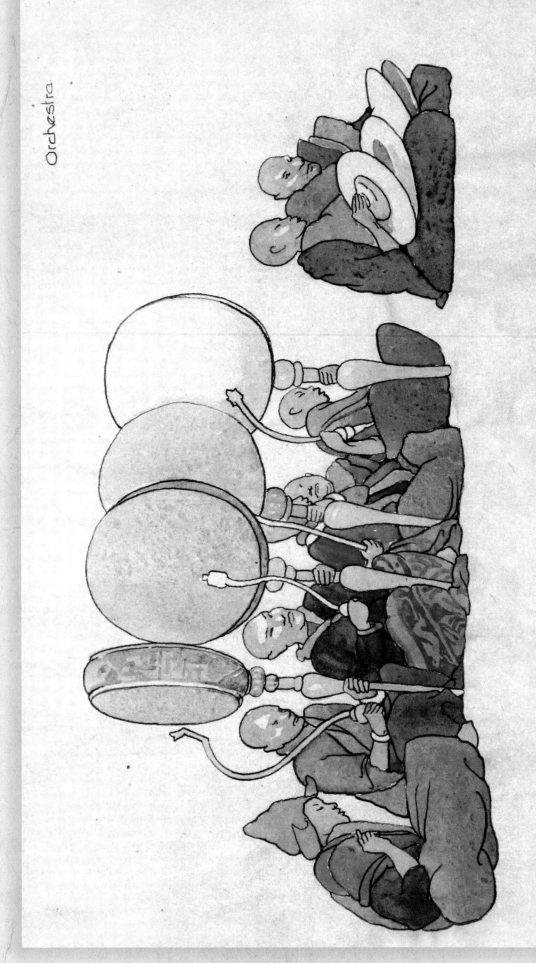

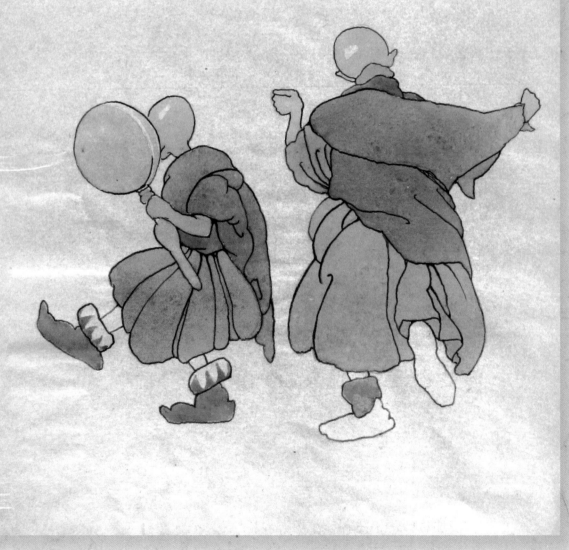

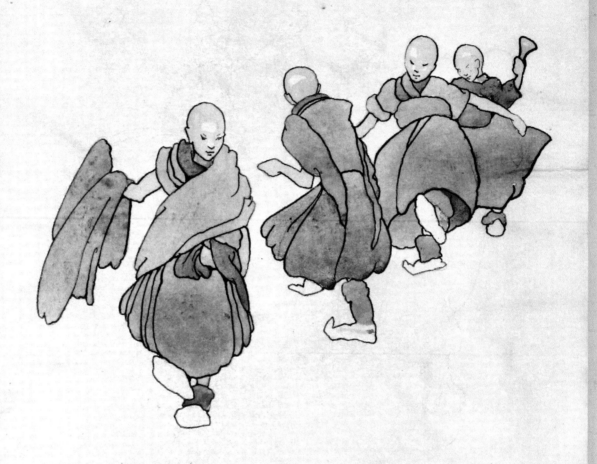

Lama dance

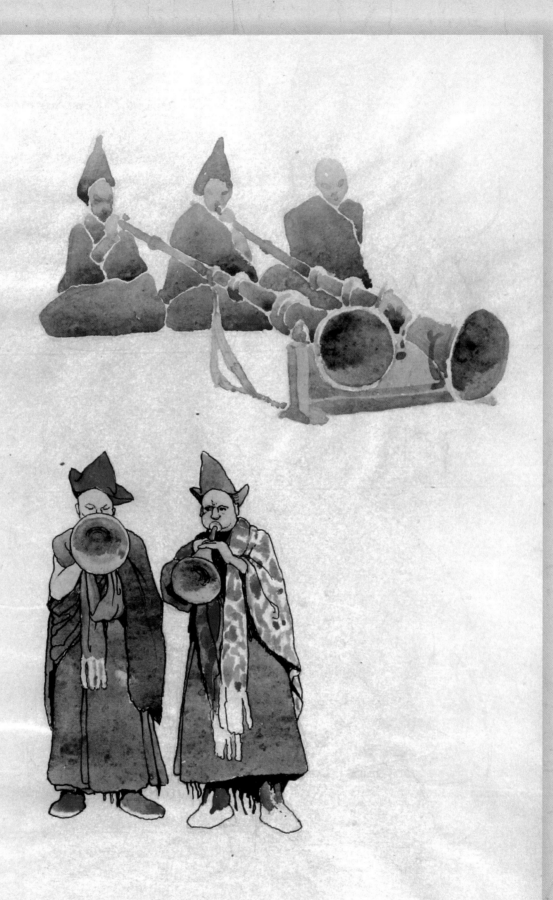

More orchestra

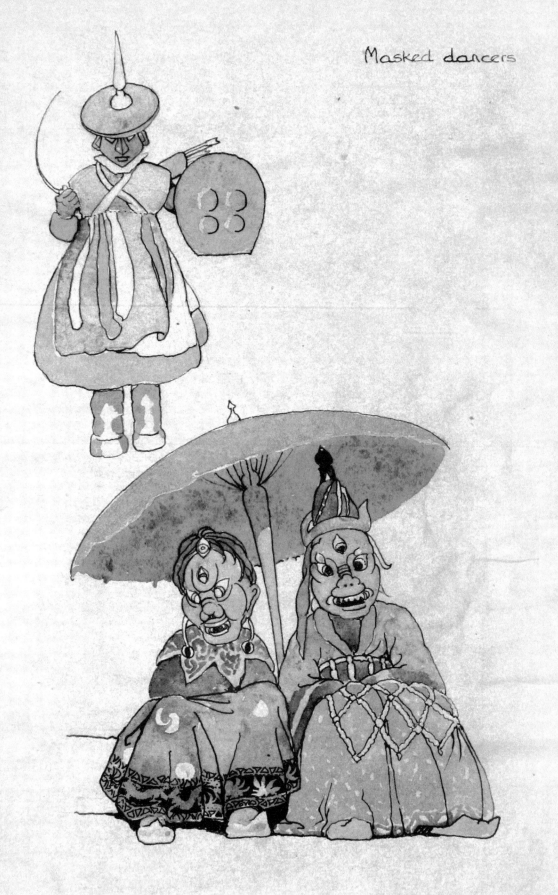

Masked dancers

39

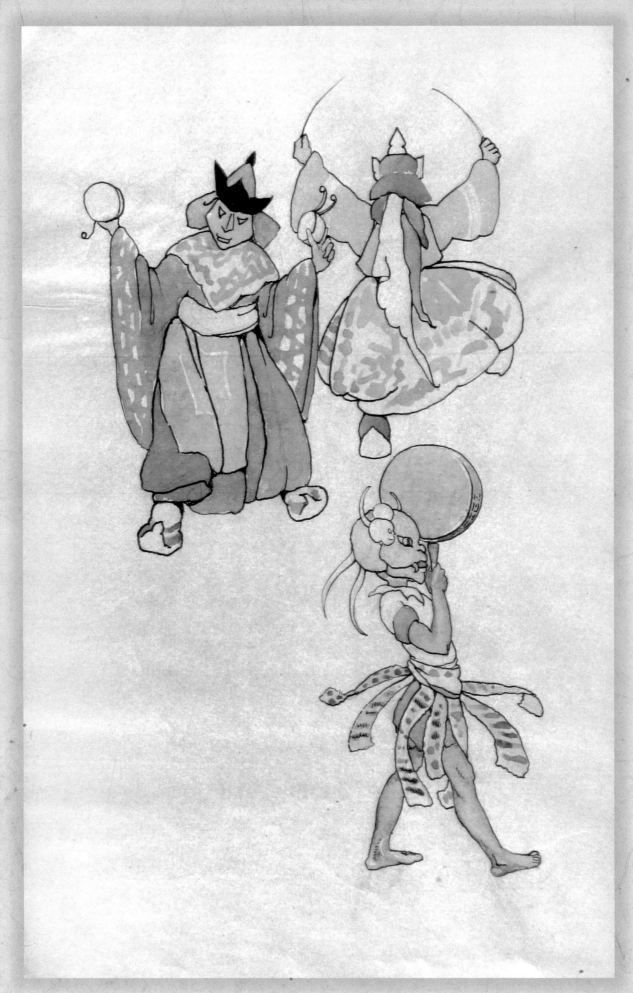

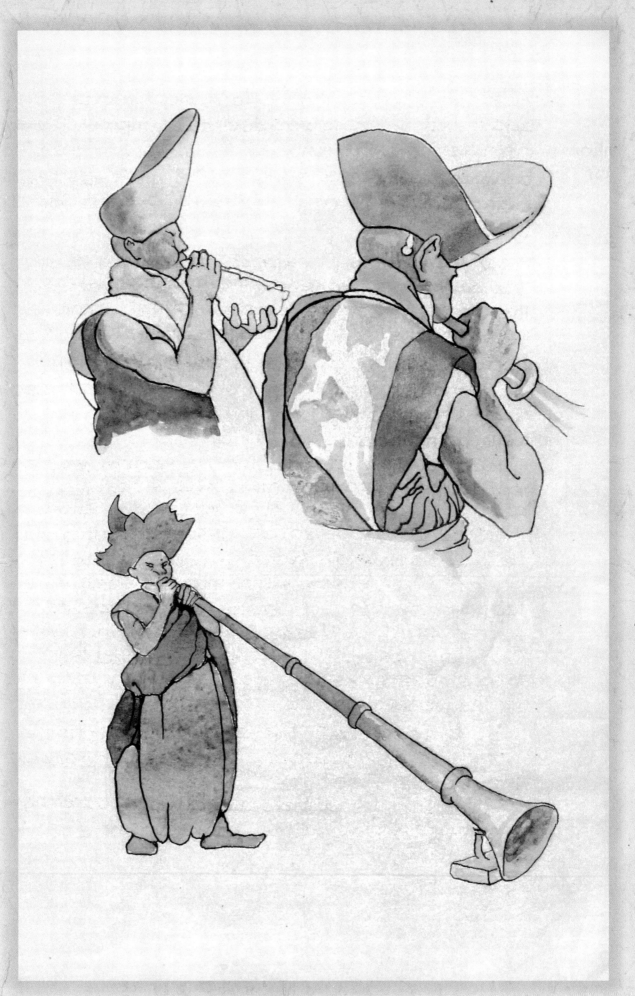

After an interval the performance began again with a fearsome duet on trumpets. These instruments are 10ft long. They make a noise between a cow & a fog-horn, the only variation being when the performer has to stop for breath!

Now, the dancers & spectators too, woke up. The orchestra quickened the music, & amidst the beating of drums, clashing cymbals, ringing bells, shrieks of audience & conch-shells, two furry 'Idags' appeared, fabulous beasts with enormous mouths & very small tummies. N.B. If you are greedy in this life, you will be re-incarnated into an 'idag.'

After a spirited dance the idags vanish-ed, leaping through the crowd & causing great consternation; four skeletons taking their place on the stage gyrated round a red & green cloth hand in hand. More shrieks & crashes, & ten men in tiger & leopard skins with large headdresses surmounted by flags came rushing onto the scene of action. These danced by themselves for some time, but finally joined in the general melee.

This concluded the evening performance

The dancers are in incessant motion the whole time.

Clothing, masks etc are always carefully removed to store after each dance.

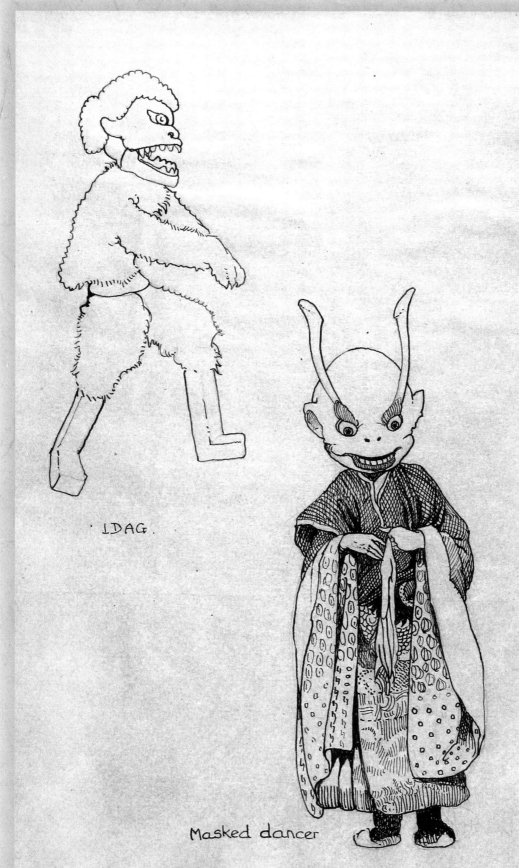

IDAG.

Masked dancer

43

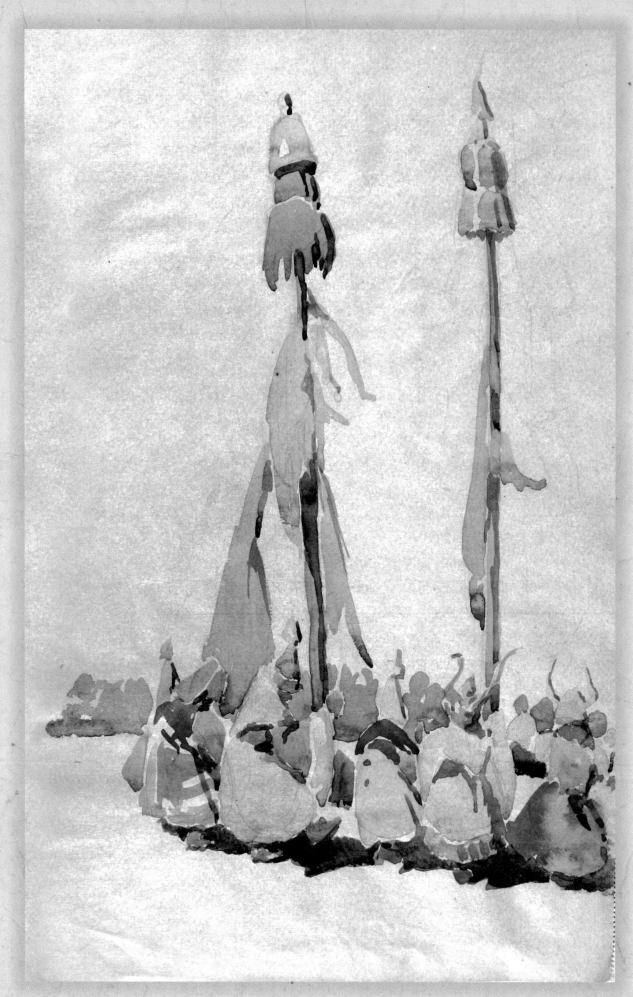

44

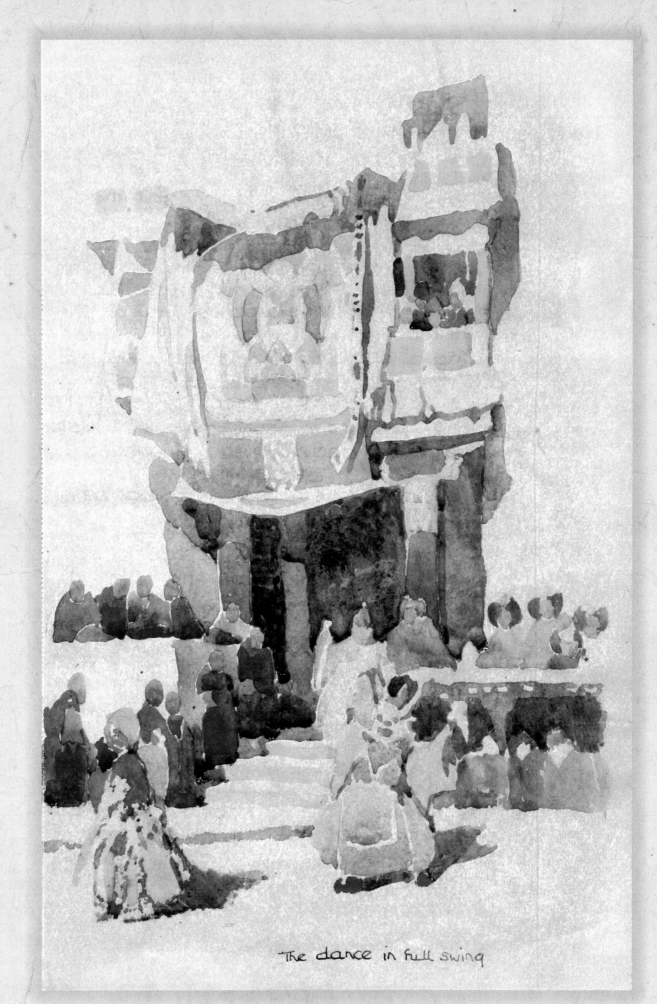

The dance in full swing

June 17th There was a long delay in starting
+ a still longer one after the mid-day
interval.
 During the first wait we examined
parts of the monastery which was very
dark inside. We saw a huge silver chorten
set with various stones, + some beautiful
embroideries. The morning dancing
was practically the same as that of the
day before.
 In the afternoon we watched a service
in the monastery. The Skushok at a
table in a dim corner appeared to be offering
sacrifices, + lamas sitting on the floor were
chanting from ancient hand illuminated
books. At intervals of a minute
bells were rung + noises like cat-calls
made.
 Presently three horses + two dogs
which had been kept in the courtyard
most of the afternoon were smeared all
over with red paint + led out at one end
only to be driven in again from the opposite
end at a furious pace, goaded by the
howls + yells of the crowd. This was
repeated three times.
Apparently these are scape-animals.
 I had been painting a fairly large
picture of the monastery front + dancers
+ was clearing up when two lamas came
+ said in shaky Urdu that the Skushok had
expressed a desire to behold the work of
art, so I followed them through the main
entrance + up a series of pitch dark

very steep stair-ways
to the Skushok's rooms
which were dingy and
ill-lit. Numerous
servants were ranged
along the walls, he sat
fat + meditative on a
chair. Conversation
was somewhat limited
as I knew two words
of Tibetan, but the lama
who spoke Urdu produced
another picture by a European, which,
he intimated had been given (much
emphasis on this) to His Reverence. I
remained dense, + after much bowing +
salaaming departed gracefully.

 At last the dancing began again. A
performer with an enormous headdress
executed a pas seul consisting chiefly
of bowing to the entrance. He was
presently joined by ten others + they
all took part in a very slow formal step.
Two small boys in brilliant costumes
then trumpeted three times at the head
of the stairs, squatting with crossed
feet as they did so. They heralded some
twenty soldiers with the most benevolent
faces, who flourished gruesome weap-
-ons + whose job was evidently that of
protecting the faithful from evil spirits.

 The red + green cloth, covering some
unknown object was placed in the centre of

the court while minstrels in coxcomb hats played for some time. Presently a solitary figure was seen gyrating at the head of the stairs; he wore a blood curdling mask with blue horns. As he descended the steps he was pursued by eight others, if possible more fearsome than himself. & they all joined in a circular dance.

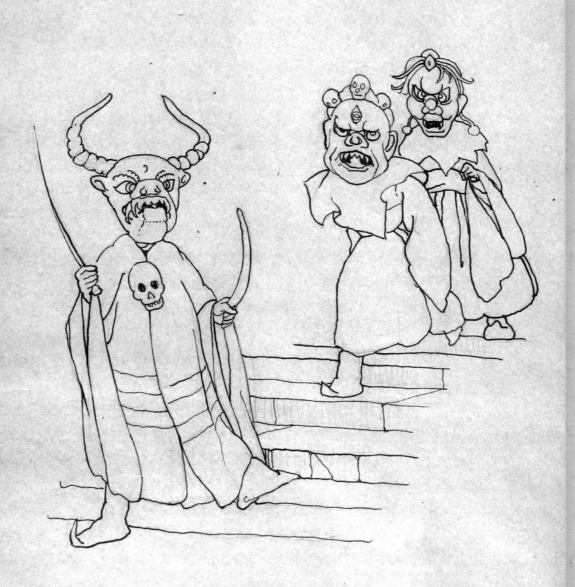

All the while, the four skeletons were sneaking on to the scene of action. They reached the inner circle where they danced stealthily for some time. Apparent-ly overcome Blue-horns + his companions disappeared, + the ghouls pounced gleefully on the cloth, rending into pieces + devouring a corpse (sham one) which lay underneath. Having gloated over their prey, they rushed up the stairs in a frantic triumphal dance.

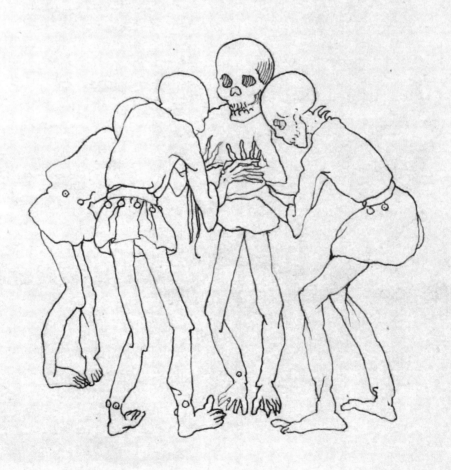

The last scene of all seemed rather
an anti-climax. Five little lama boys
carried a ponderous gentleman represent-
-ing the Skushok to a seat, + then played
round smacking each other on the head +
ragging the old man. However, they
danced remarkably well.

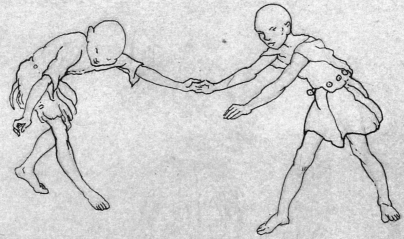

This was all except that some of the
masqueraders came next morning to ask
for bakshish whilst we were having
breakfast.
 This whole performance of course is in the
nature of a Mystery Play, + to us most of it
remained a Mystery Play indeed.
 It is however most tremendously interesting
to see a performance at present entirely
unspoilt by Western influences.

June 18
Himis
Leh

24 m.

Return to Leh. Started early & walked down to the Indus. We then mounted but the ponies after two days rest, & also homeward bound were uncontrollable. The lunch, which I had in my rücksack was a sorry sight by the time I managed to pull up.
We overtook parties of lamas returning to their various monasteries after the play, circling round every chorten along the track.

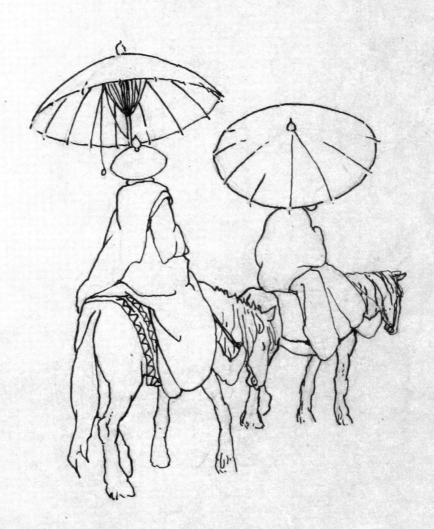

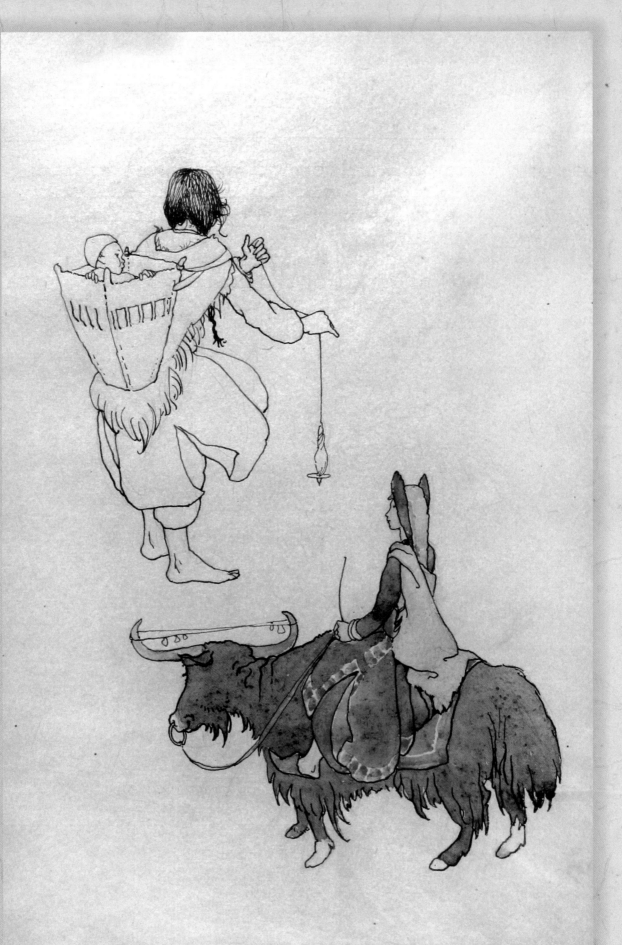

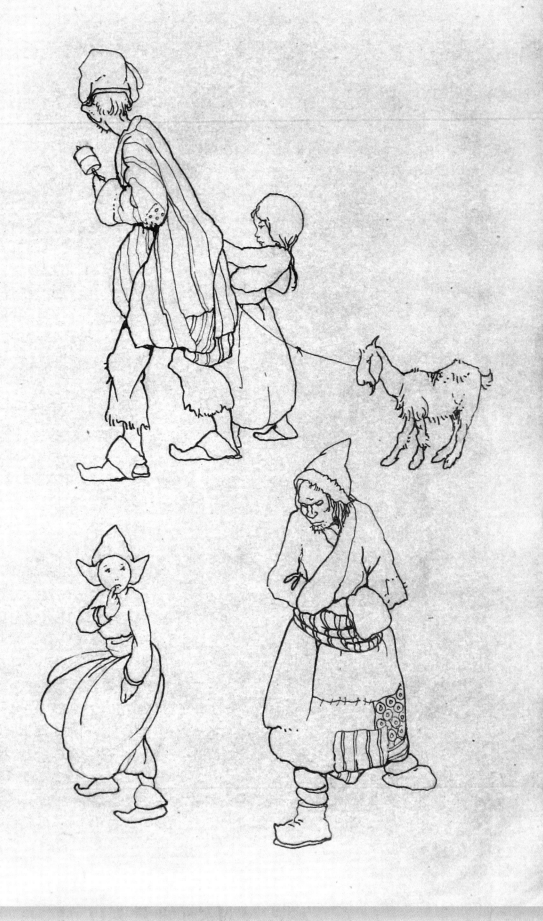

June 19-21 Halted at Leh - & explored the town
& neighbourhood.
I sketched at every possible opportunity. A
crowd of guttersnipes would wait for me
outside the Rest House & firmly accompany
me on all painting expeditions.

June 22nd Started to climb the Khardong Pass
At first the path led gently up a valley
10 m. northwards, the only troubles being heat
& the sandy condition of the track.
At 13,000 ft we passed a village Zqunglas
(good name that) with an attempt at cultivation
round it. After that the ascent got serious.
There was a snow stream beside us with
dwarfed primulae on its banks. These flowers
became tinier & tinier as the height increased.
We successively beat our altitude records
Progress got slower & slower, & we very
short of breath - We were very glad to
reach our tents & more clothing as it was
bitterly cold & there was a howling wind.
This place is 15,560 ft by our aneroid which
is probably an underestimate as it has
now done a complete circuit so we cant
take it any higher. The name of this place
is 'Polu' meaning 'patch of level ground'
hence our 'Polo' played originally on
similar circumscribed grounds.

June 23rd Snow was blowing under the tent flaps
during the night, so we didn't sleep much
12 m. owing to cold & altitude & the noise of the
wind. Got up at 5 a.m & dressed or rather
undressed. There was the most wonderful
view imaginable. The full moon was setting

54

behind the Zaskar Range, whose great 20,000 ft ice-coated piles looked like fairy castles of opal in its light, except for the highest turrets which the rising sun had fired. The Indus valley miles below us, lay in the deepest of blue shadows. It was so cold that even fast running streams were frozen in cascades of ice. After some luke warm breakfast we started to climb which was not easy, the path being a series of slippery boulders set in ice & snow, & it was too cold to stop & rest.

At about 16,500 ft I got mountain-sick, which was very annoying as I'd felt quite alright till then; however, eventually I had to give up & go back to base camp.

My uncle did about 500 ft more by which time his feet, hands, & nose were blocks of ice so he returned too. We gradually thawed in the sun, & returned to Leh about noon.

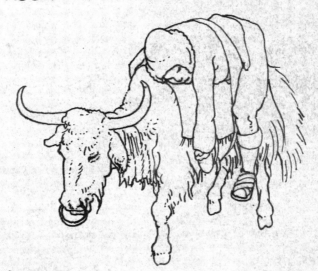

Apparently people are sometimes so sick

on the Khardong they have to negotiate it strapped onto yaks like their baggage. Personally, unless I were too sick to be responsible for my actions, I would stagger along on my own legs rather than accept the aid of a yak who always has a generous supply of fleas.

June 24th

We were invited by the Naib Tehsildar to watch a polo match. He directed us to take photos, specified the number of copies, & even told us where to get them developed!

The game was played in a side street of Leh bazaar. We were seated on a raised mud platform with several Tibetan spectators, near which a drum & pipe band played selections. Large stones served as goal-posts.

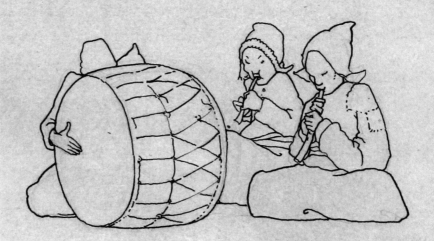

The polo was, we gathered, not quite so wild
+ woolly, as most performances in this
country – still it was most amusing.
At first there were only two players, but more
kept joining in, until the scrum was terrific.
The costumes were unique, + pigtails the
finishing touch.
The standard of play was high, but of course
not as fast as an ordinary game.
Occasionally a pony would charge into
the main street, but the shoppers were quite
unmoved.
A pigtailed attendant rushed onto the
ground at intervals to collect fallen hats.
The spectators gave advice all the time!
Play continued for an hour without any
change of mount, after which the ponies
did not seem in the least the worse for
wear.

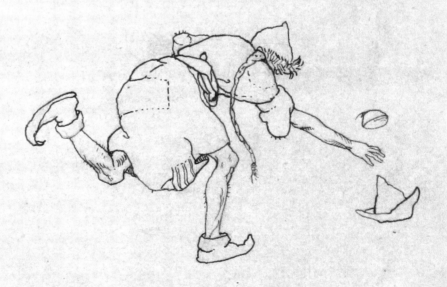

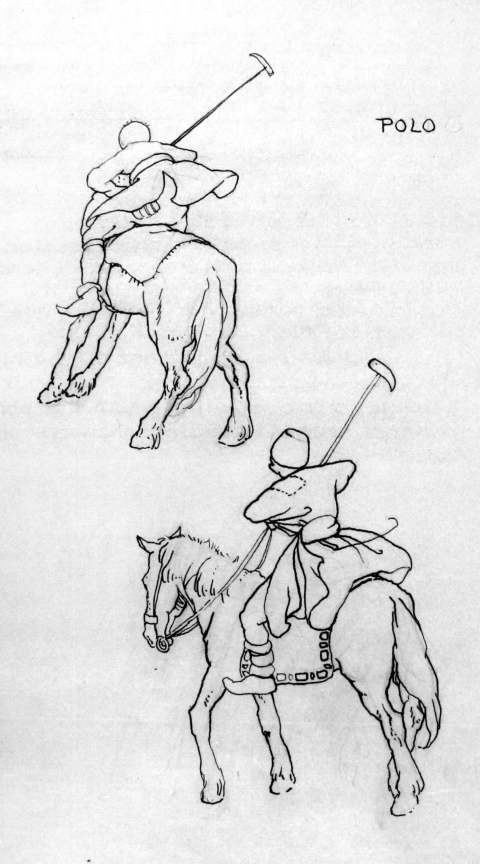

POLO

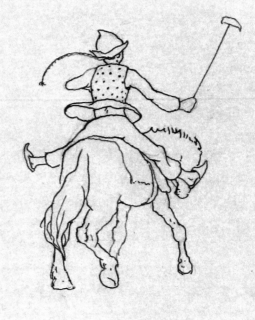

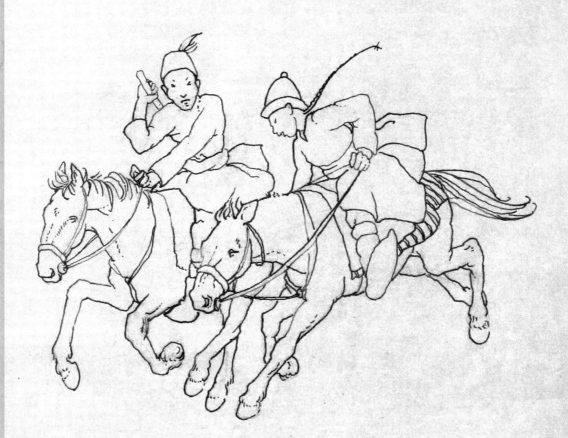

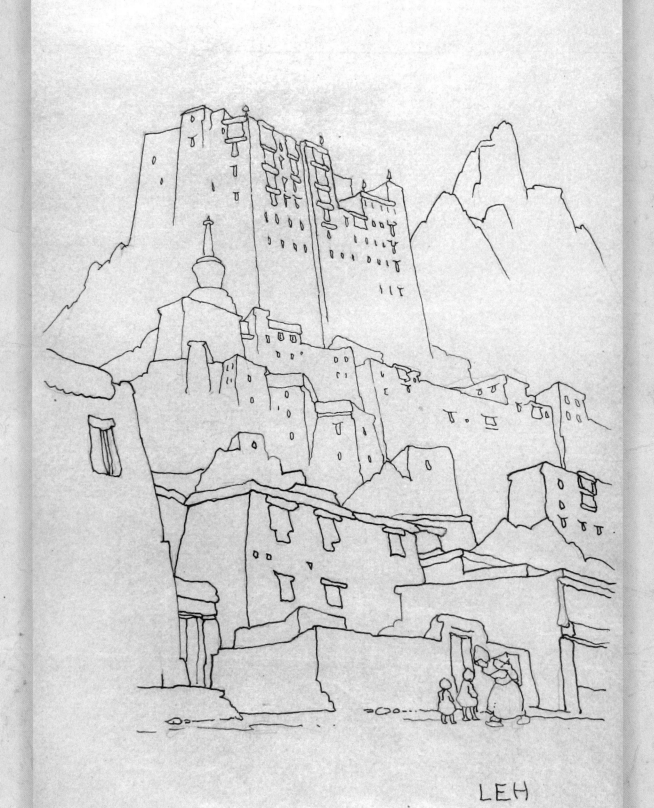

LEH

June 25th
Leh
Nimu
19 m.

Early in the morning we started on our long homeward journey. The Bishop accompanied us for 3 or 4 miles lending us two ponies.
The day was mercifully cold, + there were even a few drops of rain.
We heard a strange bellowing which a coolie said was a sharpu. My uncle was convinced it was an 'Ldaq'

June 26th
Nimu
Saspul
13 m

A distressing feature of the homeward way is that there are far more up hills than there were downhills on the way out. However it is much cooler.
Crops + flowers have come on wonderfully. Wheat, beans + Himalayan pea are all cultivated in the same field. Great hedges of catmint five feet high are out all mixed up with wild roses.

June 27th
Saspul
Nurla
14½ m

Same remarks as yesterday.
Four pigeons flew just a few yards ahead of us for three miles.
We saw three young bara-singh.

June 28th
Nurla
Lama-
-yuru
19 m.

After a few hours marching we said goodbye to the Indus. Proceeding up a large stream without a name we came to an ideal spot for bathing. Several rocks had fallen into the stream + formed a perfect swimming bath. This was much appreciated. We had to walk fast after, to dry such of our clothes as had formed bathing suits. A motion to return to the spot as we are halting tomorrow was carried unanimously, but as we toiled up the narrow gorge to Lamayuru dissentient voices began to be heard + eventually the motion was negatived.

We had just finished tea at 6.30 when the cook announced dinner.

June 29th Halted at Lamayuru, rightly called the Capital of Hobgoblinland.

June 30th
Lama-
-yuru
Kharbu
15 m.
Got up very early as we wanted to cross the Fotula before it got unpleasant-ly hot; + we reached the top by 8 a.m. We are getting awfully good at climbing.

July 1st
Kharbu
Mulbekh
14 m.
Crossed the Namykala + reached Mul-bekh at noon. About ½ mile from the village is a rock 20ft high on which a gigantic Buddha is carved. Below, some children led by a lama were dancing to vocal + instrumental music; the boys holding sort of brooms in one hand decorated with grasses + the heads of yellow roses, the girls with lacey nets of the petals of the same flowers which are very common in this district.

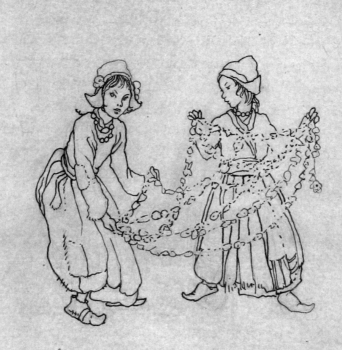

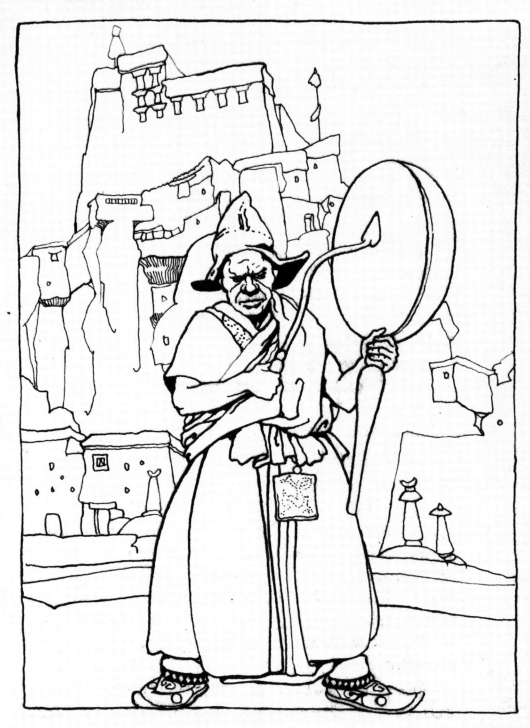

A lama of Lama-yuru
 Got holier as dirtier he grew.
He was once heard to say
 It is twelve years to·day
Since I last washed my hands, that
 is true.

Our times show a consistent improvment on those coming. We sometimes gain 1½ hrs on a march.

We went to have a bathe in the Wagqachu but it was so cold I only got in up to my ankles.

There is a shortcut from Kharbu here which the route-book calls a camel track! It is a goat track at an angle of 45°

July 2nd
Mulbekh
Kargil
24 m.

The longest stage - The deep barren gorges we remembered from the outward trek, were lined with red & double yellow roses. Each bush was so covered with blossom that leaves & stems were scarcely visible.

Having reached the Rest House, my Uncle went on to the town to get letters, so did an additional two miles. Not bad for an old man

July 3rd
Kargil
S. Kharbu
16 m.

An uneventful march - nice & cool, & a fearful wind storm all night.

July 4th
Kharbu
Dras
20 m.

A bit too cool, strong wind & drizzle against us. The flowers were simply wonderful, which was a surprise as we had left Dras district almost more of a wilder--ness than the rest of Ladakh.

We had great difficulty in getting a fire in the evening, as the woodman was an elusive gent, & there was no firewood.

July 5th
Dras
Matayan
12 m.

As this was a short march, we allowed ourselves the luxury of staying in bed till 6 a.m, also of a sit-down lunch when we arrived.

Again the flowers were a great delight. Masses of yellow hemlock covered with bronze & white moths decorated the left hand

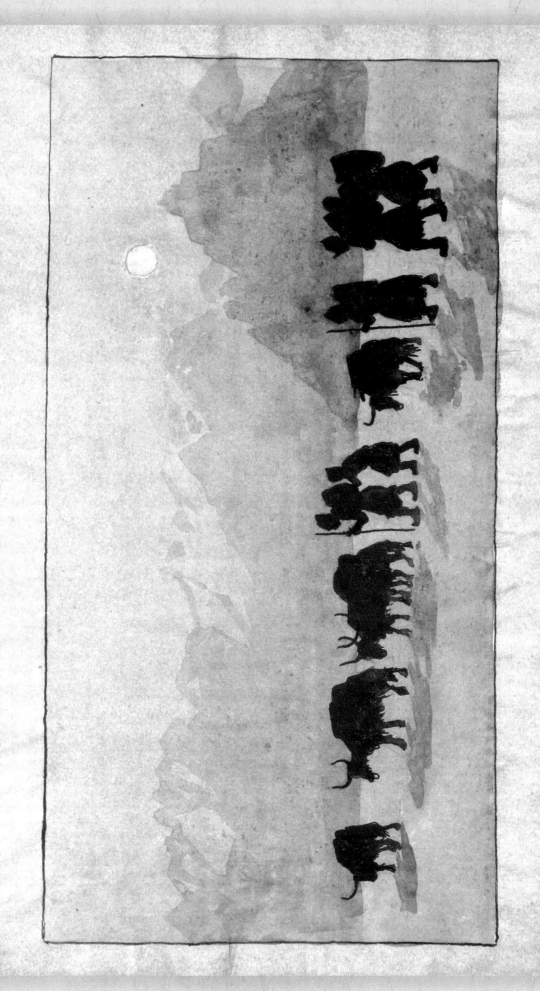

65

river banks, while to our right were regiments of white-hot-poker. Later we came to fields of asters + anemonies, measuring 4" across

In the afternoon a fierce looking Englishman appeared from the Zoqi direction, walking at about 8 m per hour. He took one look at us + then streaked off in the direction of Dras. His kit arrived later, but we never saw him again.

July 6th
Matayan
Machoi
Baltal

18 m.

Started at 6 a.m likewise the rain which as we climbed turned to sleet + then snow. The slush underfoot was fearsome, the streams swollen + bridge--less; it was bitterly cold, with a driving wind; the track was obliterated + we kept slipping into snow drifts. Reaching Machoi serai we got a fire lit, at which we steamed ourselves, as we were soaked to the skin The baggage turned up after some time but the ponymen who all have a great aver--sion for Machoi were anxious to press on in spite of the snow, so we had lunch, dried a few more clothes, + then started off again feeling much better as the sun was struggling through the mist. We crossed several precarious snow bridges, + avalanches were rumbling all round us.

At length we reached the summit + alas, left Ladakh, lamas + pigtails all behind us. Same old indefatigable cuckoo was there: no wonder it gets other birds to lay its eggs for it.

At the birch forest we found a party of coolies digging down into a crevasse where an entire caravan had been swept

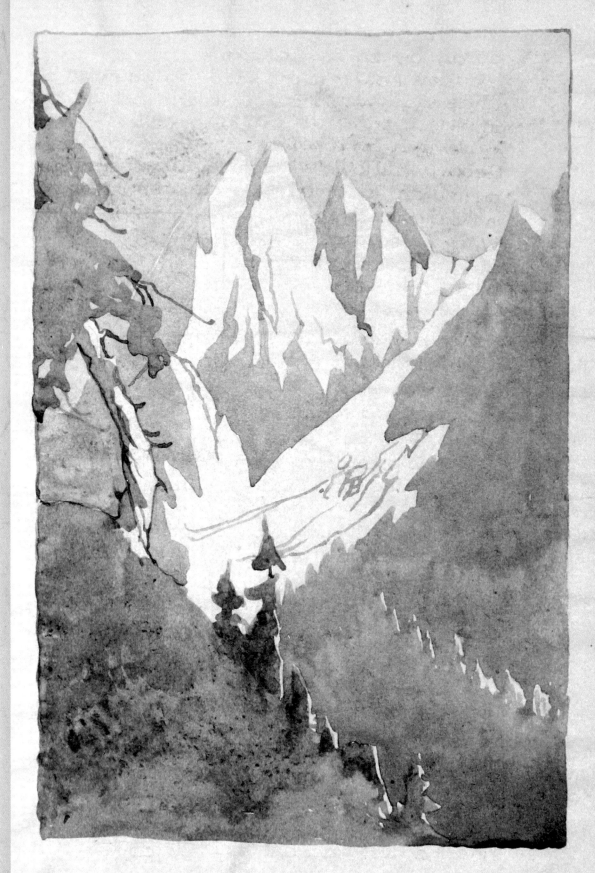

N.º Sonamarq

away by an avalanche.
We were now surrounded by 50 miles of
Chelsea flower Show : perfect rock gardens
divided by great banks of taller flowers
& all with a perfect background of snows.
Geum, wallflowers, companulae, gentian,
primulae, columbines & anemonies were
in the greatest masses.
When we reached Baltal
our tents were already
pitched, so we lit a
huge camp fire & fin-
-ished drying our clothes.

July 7th Wet day - We got
Baltal drenched again, + reach-
Sonamarg. -ed Sonamarg very cold.
 9.m. to find the serai occupied
so had to pitch dripping tents.

July 8th A glorious day - we gradually thawed
Sonamarg in the sun, having been frozen stiff during
Gund the night. Thousands of logs were being
14 m. floated down the streams to the depôt at
Granderbal, & at intervals men were
clearing the jams. They would sometimes
walk right out onto the river on these blocks
to find the key log; & having loosened it
would have to leap like kangaroos for the
shore as the current carried the timber on -
-wards at incredible speed.

July 9th Getting terribly hot as we descend the
Gund valley. We meet crowds of typical hill
Kangan gipsies. I went down to the Sind to
finish a sketch, begun on the way out, to
find the river had entirely altered its course.

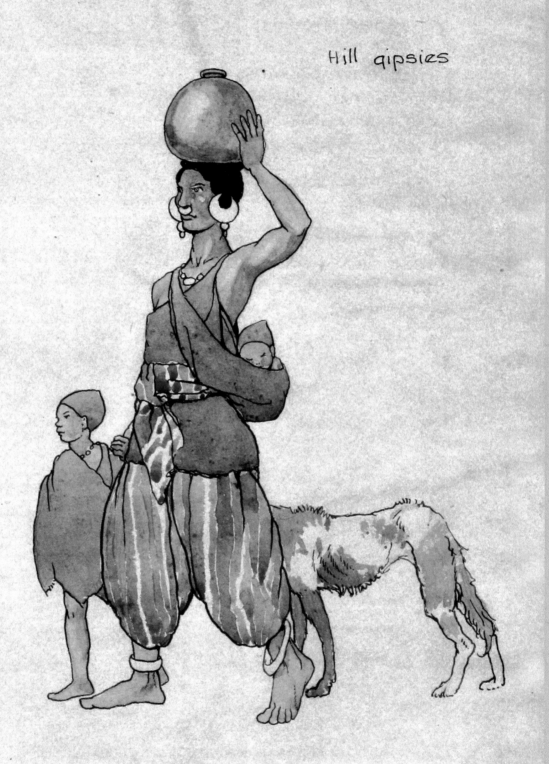

Hill gipsies

July 10th
Kangan
Srinagar
25 m.

We arrived at Granderbal quite early & waited for our transport; & when that arrived went in tongas to Srinagar, which seemed very luxurious, as Ladakh knows no vehicles at all.

So we completed 560 miles in 50 days of which only 36 were marching days.

My Uncle shaved off his very fine beard (I think he had hoped to be mistaken for Zeus) & I washed & brushed, so in a few hours we were quite indistinguish--able from ordinary people.

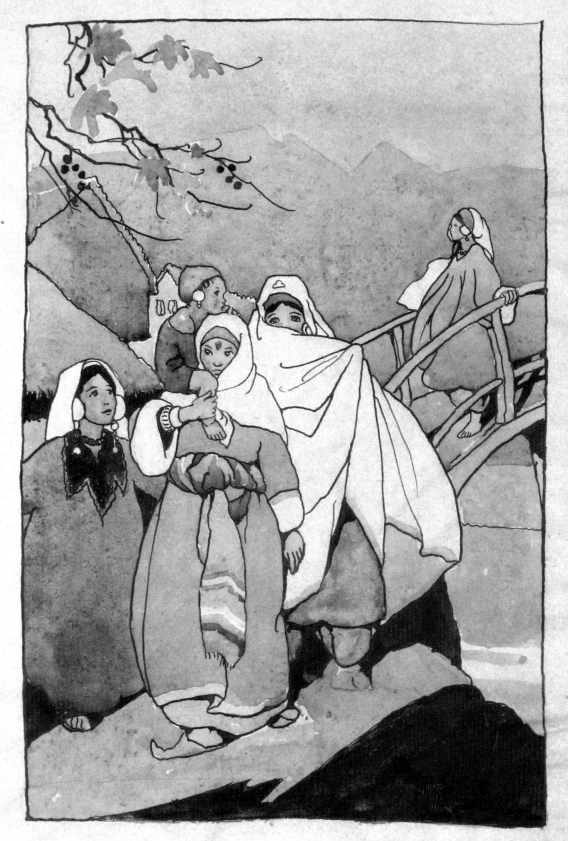

Srinagar

HOW THE DIARIES WERE INHERITED

There are two diaries. Sheila Harvey inherited the one that is the main part of this book, from Vera Iliff, Arthur's second wife and Mollie's friend. She died a little while after Arthur in her 70's. Sheila and Jeremy knew Anne, Arthur and Vera's youngest child, when she was at school near them and they had made and kept contact with the family. Sheila was touched and delighted that Vera had wanted Mollie's diary to return to her birth family. We think this diary was prepared by Mollie for publication.

What follows are some additional pictures from the diary that Jenifer Rohde was given by Beatrix Molesworth. Beatrix had been asked by David Molesworth, Mollie's brother, to take care of the diary whilst he was working abroad and after his attempt to get it published had failed. He had approached Lady Reading, widow of the Viceroy of the sub-continent from 1921 to 1926, about publication but sadly she died within days of receiving his copy of the diary. We do not know whether she knew Mollie but, as founder of the Lady Reading Hospital in Peshawar, we know of her interest in and commitment to the area.

The two diaries are very similar but not identical. Some images appear in one but not the other and the images and text are arranged differently on the page. The pictures in this second diary are in some places numbered and lettered, which suggest that Mollie used this copy to produce her final version. There is also a traced figure tucked into the prepared version, which is of an image in the second diary, confirming that this may have been the way Mollie worked.

PAINTINGS FROM
DIARY 2

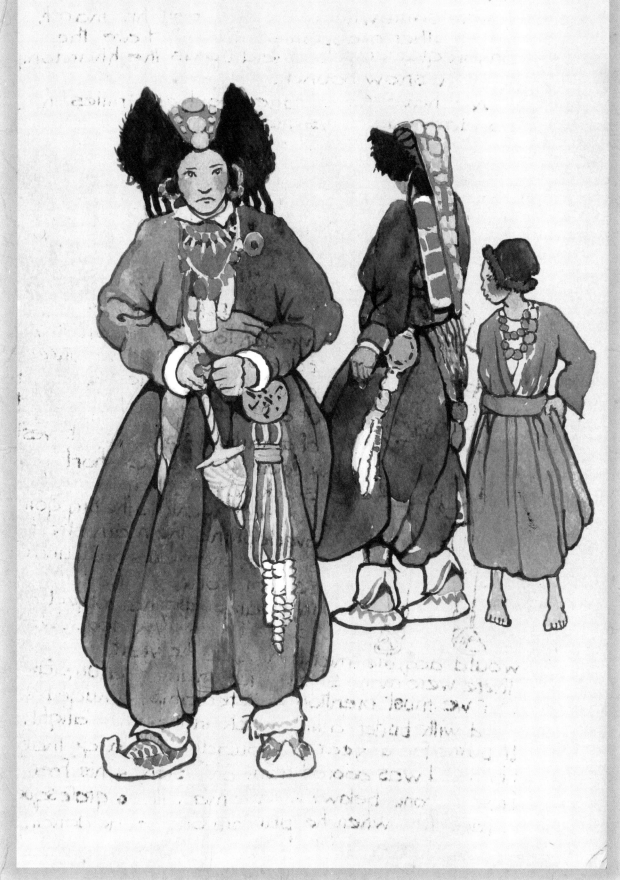

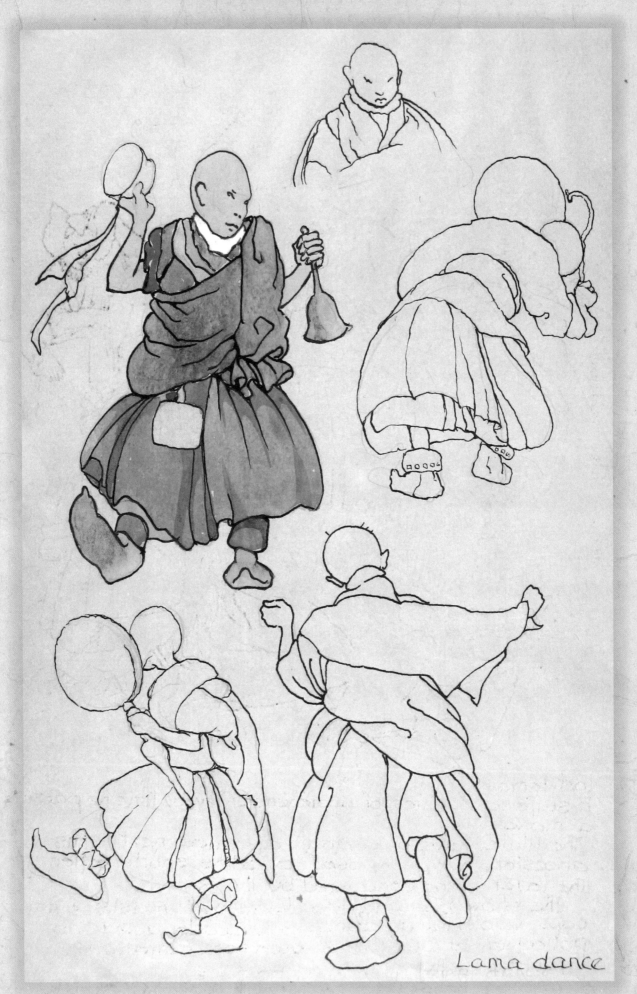

Lama dance

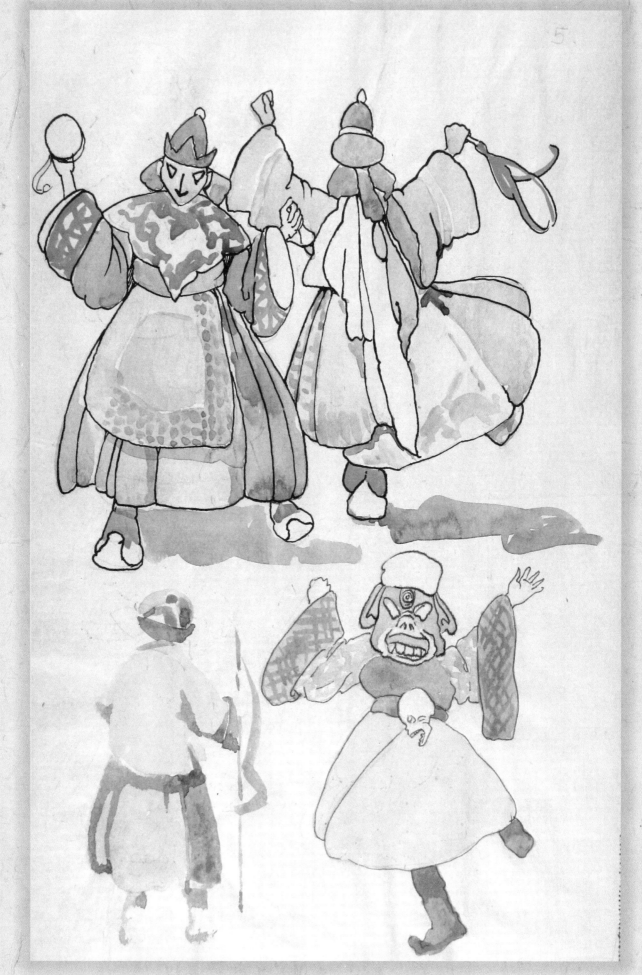

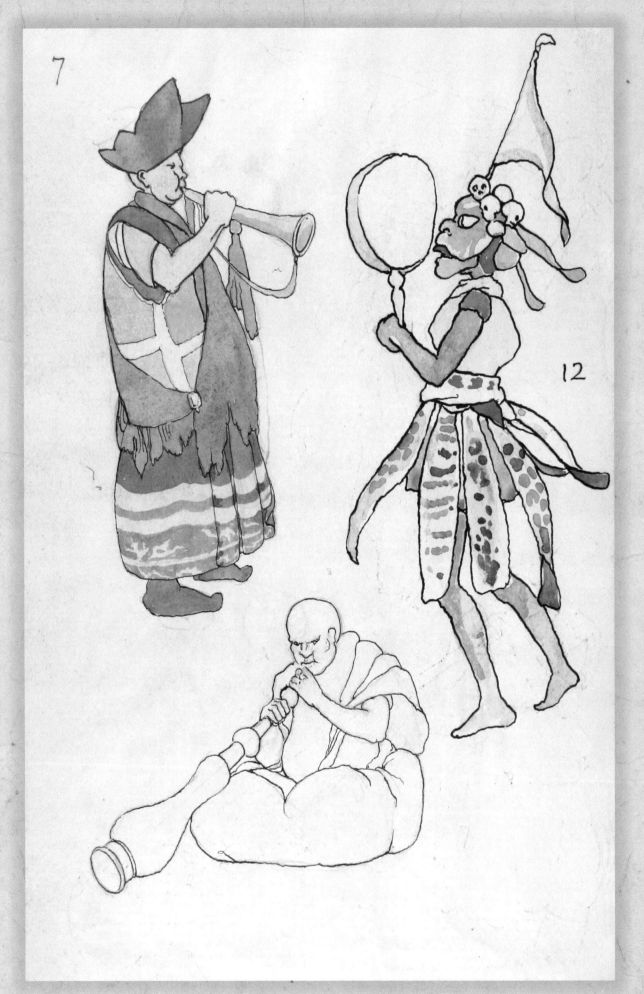

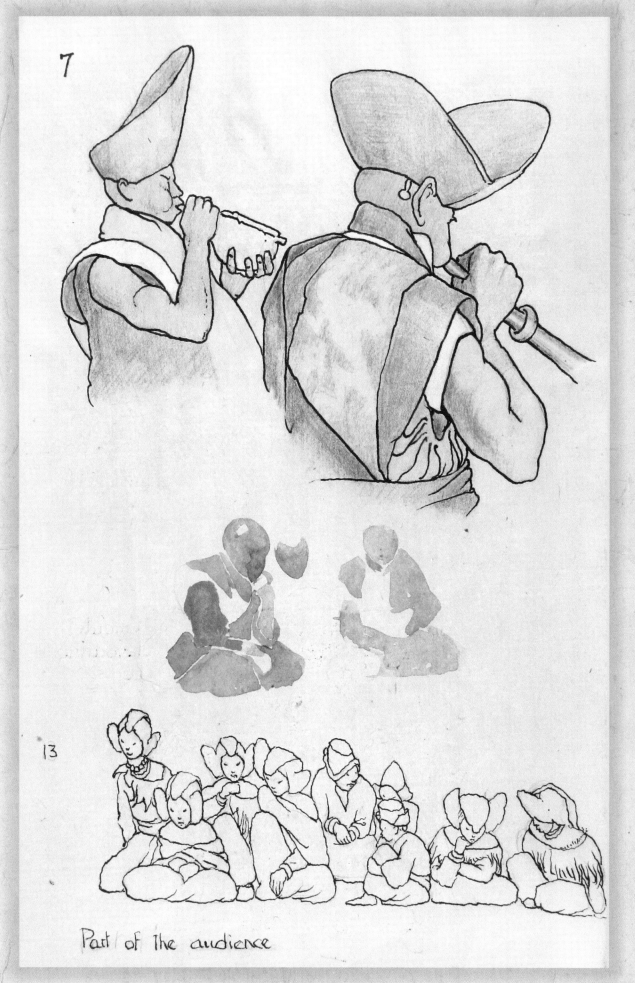

Part of the audience

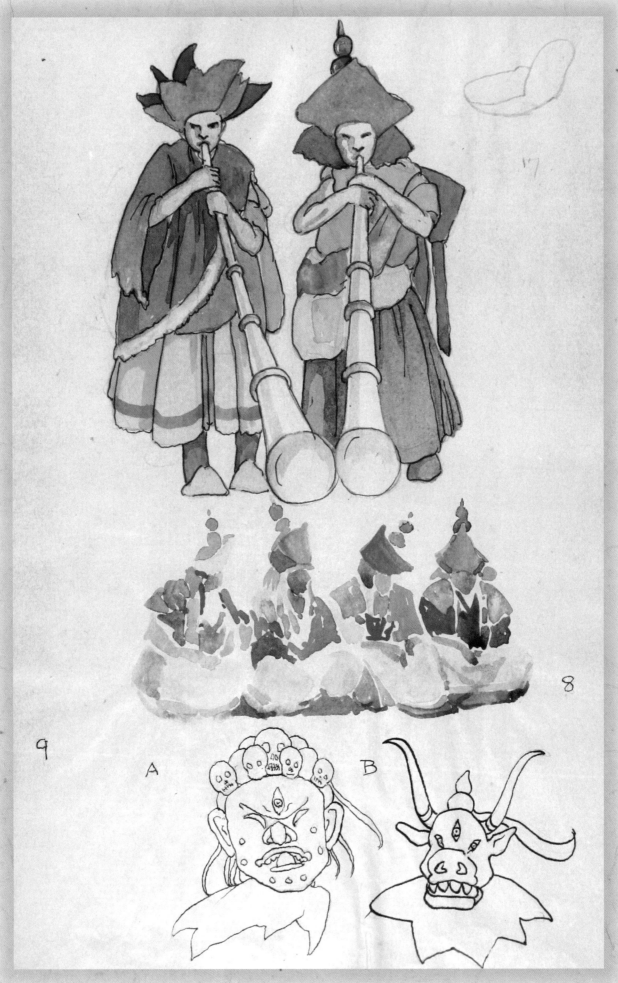

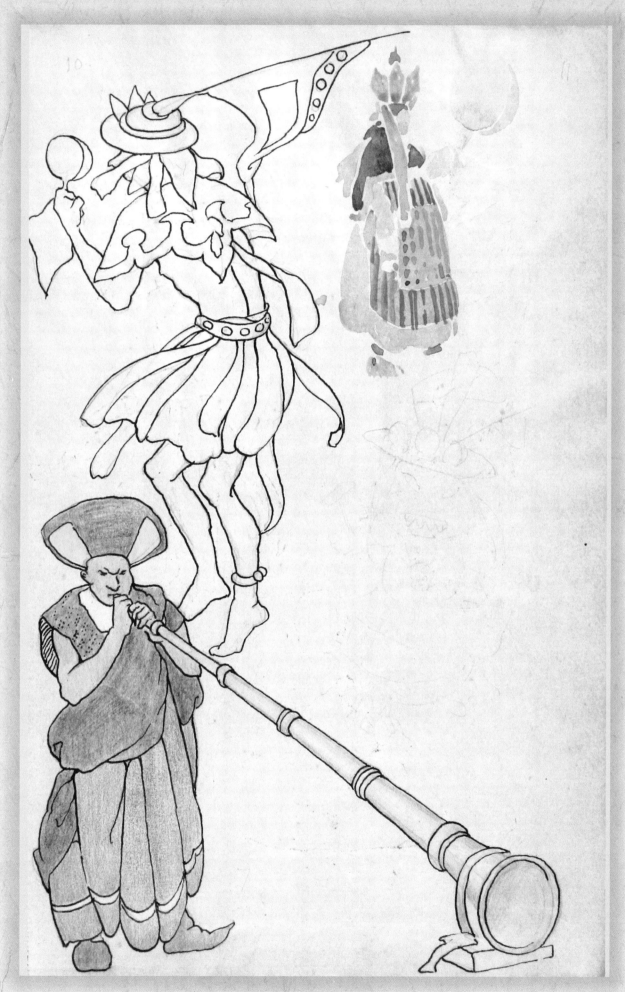

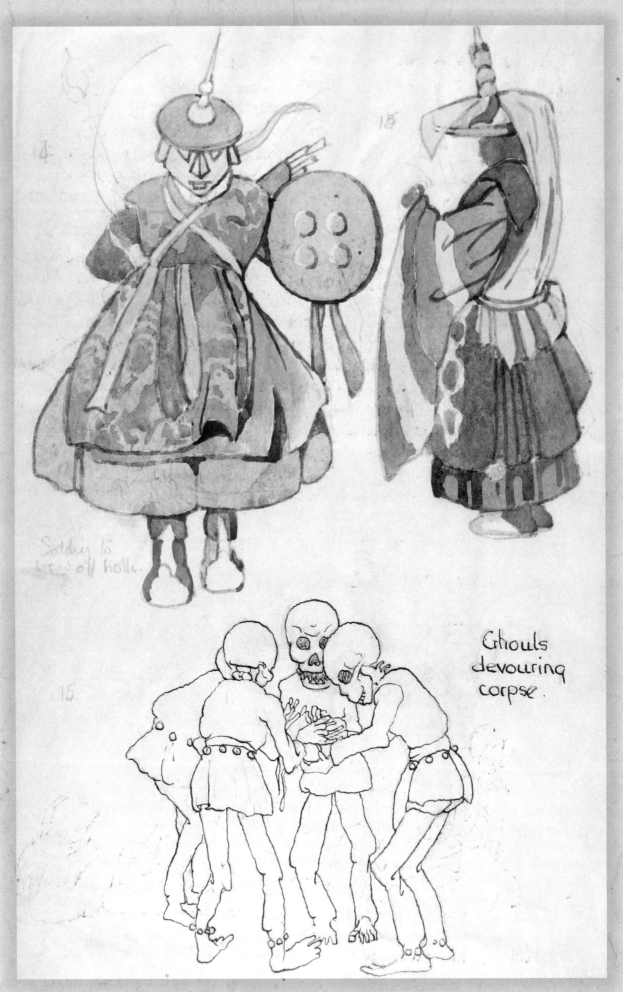

14

15

Soldier to ~~keep off~~ trolls.

Ghouls
devouring
corpse.

15

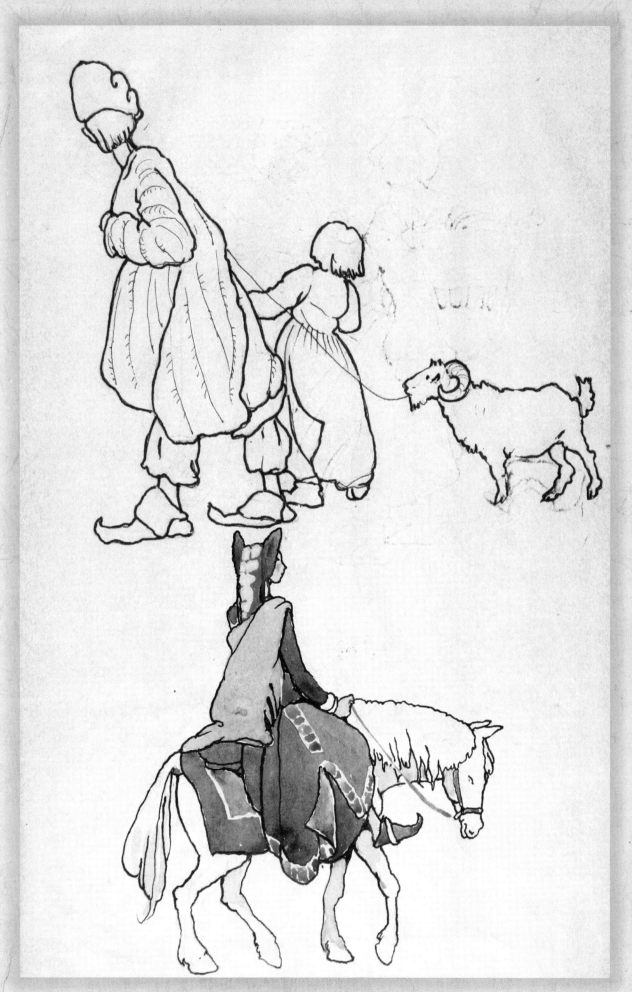

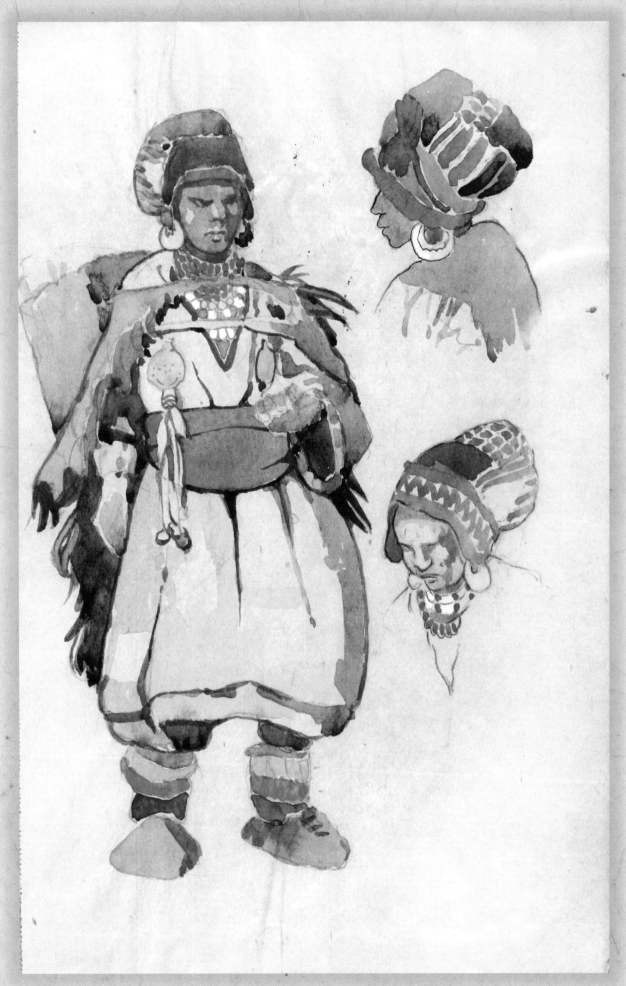

86

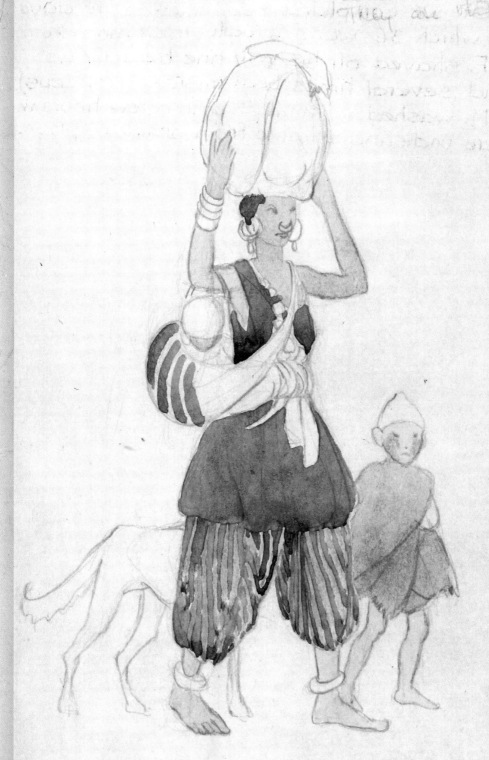

Hill gipsies of Sind &
Liddar districts

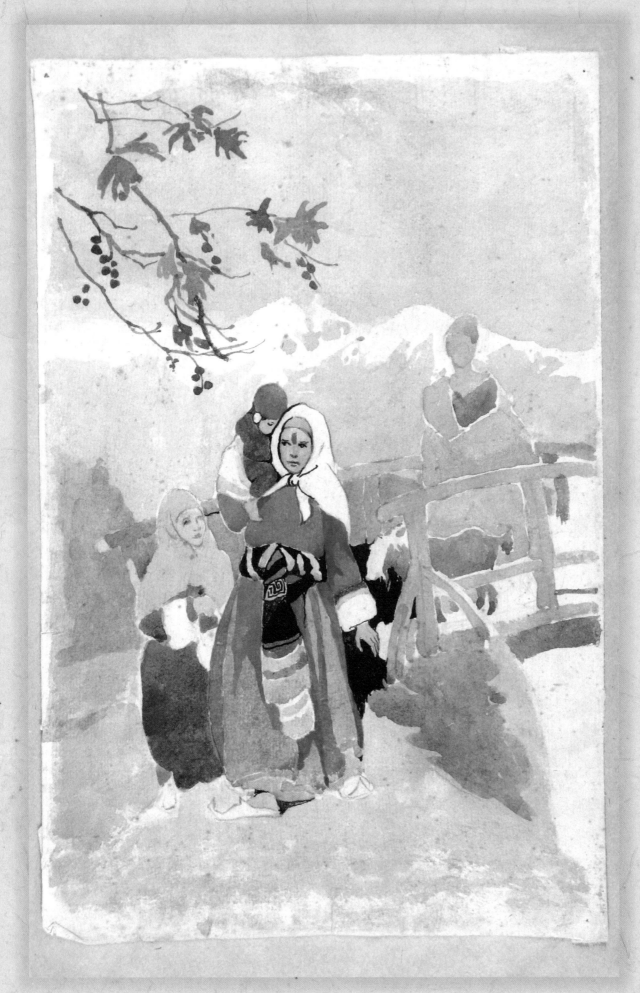

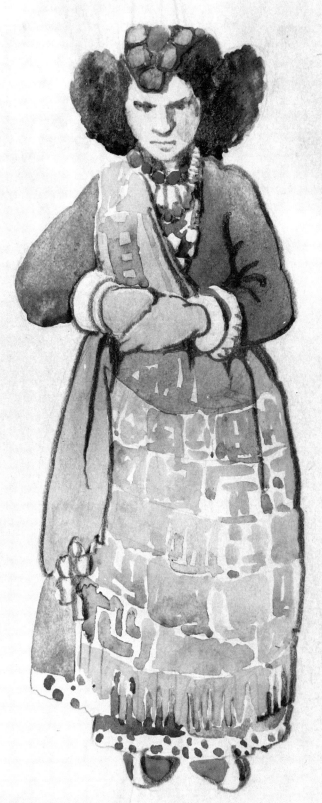

The Queen
of Ladakh

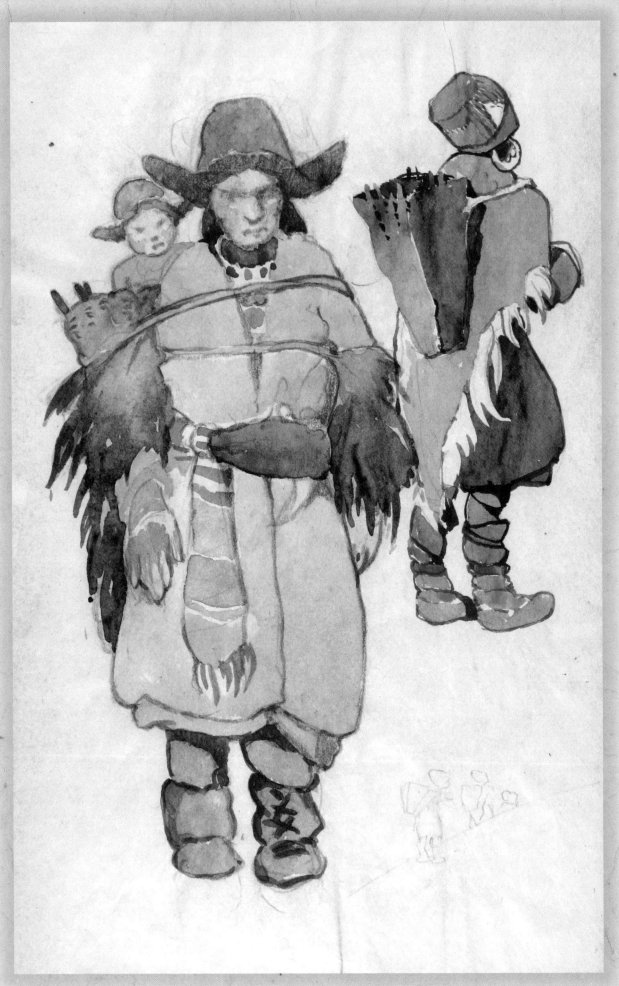